O'Keeffe and Me

O'Keeffe and Me

A Treasured Friendship

Ralph Looney

University Press of Colorado

1995

Published by the University Press of Colorado
P.O. Box 849, Niwot, Colorado 80544

The University Press of Colorado is a cooperative publishing enterprise
supported, in part, by Adams State College, Colorado State University, Fort Lewis College,
Mesa State College, Metropolitan State College of Denver, University of Colorado,
University of Northern Colorado, University of Southern Colorado, and
Western State College of Colorado.

The paper used in this publication meets the minimum requirements of the American National
Standard for Information Sciences—Permanence of Paper for Printed Materials.
ANSI Z39.48–1984.

Library of Congress Cataloging-in-Publication Data

Looney, Ralph, 1924–
O'Keeffe and me : a treasured friendship / Ralph Looney.
p. cm.
Includes index.
ISBN: 0-87081-406-0 (alk. paper)
1. O'Keeffe, Georgia, 1887–1986—Friends and associates.
2. Looney, Ralph, 1924– —Friends and associates. I. Title.
N6537.039L66 1995
759.13—dc20
[B]
95-33195 CIP

10 9 8 7 6 5 4 3 2

To my beloved wife, Clara

Contents

Author's Notes

One of the first things I learned as a cub reporter was the importance of making good notes. Without them, one is lost. I learned quickly that it pays to transcribe them as soon as possible after an interview. I also learned that it helps enormously if you save them. This memoir of our dear friend Georgia O'Keeffe is possible only because I saved every note, every article and every photograph of this marvelous personality. I realized early on in our friendship that I'd write a book about her someday and made certain my material survived several moves over a thirty-one-year period.

But any book requires much more than notes; it requires support, encouragement and advice. Fortunately, that was well provided by my wife, Clara — my best critic — and others. At the top of the list is my dear friend "Ol'" Max Evans, the best writer I know, who always says it like it is. His suggestions were most worthwhile. Another old friend, Dan Thomasson, took time from running the Scripps Howard News Service to offer support and ideas. David Carlson, then at *The Albuquerque Tribune,* was helpful in the computer department. All have my gratitude.

A special word of thanks is reserved for Richard Friedman, my neighbor, who displayed incredible patience in guiding me through the intricacies of WordPerfect. He deserves some kind of medal.

Foreword
Introducing the Reader to the Worlds of Ralph Looney and Georgia O'Keeffe

Author/editor Ralph Looney is a rarity. Humanity is made up of those few who contribute to our betterment and the vast majority who receive those gifts. Ralph Looney is clearly one of the former. When Ralph and O'Keeffe first shook hands, two sources of largesse met.

Looney, like O'Keeffe, has the dedication and skill to take on challenging subjects and see them to fruition. A fine example is his haunting series of articles, written in 1970, on the plight of the Navajo Indians. Long before Native American culture became popular, Ralph was putting his considerable talents and deep feelings for these people before the public. The *Albuquerque Tribune* series won him a Robert F. Kennedy Award for revealing so vividly the poverty of and discrimination against this valiant tribe. I feel certain that today he would be awarded a Pulitzer.

Another task Ralph took on with the same dedication was becoming a founding member of the New Mexico State Film Commission. He knew this environmentally clean, come-and-go industry would enormously benefit the relatively poor, colorful state of New Mexico both culturally and financially, and it would open doors for a great deal of untapped talent. As *Albuquerque Tribune* city editor, he publicized heavily the effort to attract movie production to New Mexico, writing most of the stories himself. He never gave up, and he was right on all counts. The state generated income

in excess of $500 million; several talent agencies opened; and a branch of the Screen Actor's Guild is still active in finding employment for many who otherwise would not have had the opportunity. In fact, the effort was so well executed that many other states successfully modeled their own cinema commissions after that of New Mexico.

More could be said about his advancement from editor of *The Albuquerque Tribune* to editor of Denver's *Rocky Mountain News* — the Scripps Howard flagship paper whose circulation and quality he immediately boosted — and even more could justifiably be said of his many other achievements. However, this book is not his life story. Rather, it is the story of Georgia O'Keeffe and her very special friendship with Ralph Looney and his wife, Clara.

O'Keeffe was already world-famous in her craving for privacy; however, she had come to the reluctant but pragmatic conclusion that she must permit some publicity to maintain even her simple lifestyle. Her conflicting feelings presented deep contradictions to Ralph and Clara on their first meetings with the recluse. To Ralph, O'Keeffe was an enigmatic challenge, sometimes inscrutable, often playful, and often openly honest to the point of bluntness. Soon, a rare and magnetic communication began to develop, and she started to trust Ralph and Clara, enjoying their company and sharing her feelings with them.

Looney, being a dedicated professional in his own field, kept meticulous notes of their conversations and meanderings in her beloved desert. We are fortunate indeed that they came together and that their friendship is shared with us in these reminiscences and photographs.

We learn in many ways that O'Keeffe could be a risky enemy but an extremely loyal friend. We could hardly find a better example of this loyalty than her attendance at Ralph's first book signing, back in 1969, for his still popular book *Haunted Highways*. Not only did she manage the trip down from Abiquiu to Albuquerque — at age eighty-two — but when she arrived at the signing, she took charge of hanging the display photos from Ralph's book. She also gave greatly of her precious energy, posing for pictures and mingling with the crowd. Ralph and Clara were highly honored and pleased by this display of friendship and her relinquishment of her fabled privacy on their behalf.

In addition to sharing her home, her desert, her paintings and some of her dreams and thoughts on contemporaries, O'Keeffe gave of her treasured time. Nothing underscores the depth of her friendship for Ralph more than her overriding her natural reluctance to be photographed. There was an almost mystical connection between Georgia, Ralph and his camera. Although she usually didn't wish to be photographed smiling, some of the shots actually reveal her laughing. This series of photos is the most revealing of the inner O'Keeffe since those of her husband and Svengali, Alfred Stieglitz. On average, considering the shorter period of time that Ralph knew her, Looney's photos are far superior.

At first glance, O'Keeffe's stare might seem one of sardonic superiority. However, on closer inspection, what her expression really conveys is, "You do not know as much as you think, friend, just as I." Another remarkable aspect of Looney's photos is the grace of her hands. They appear strong enough to crack walnuts and delicate enough to caress butterflies, perfectly expressing the major contradictions of her artistic genius and psyche.

We have been blessed that these two talents — O'Keeffe and Looney — so energetically and unexpectedly came together to share with us their unique and inimitable visions of the universe and to reaffirm the comforting simplicity of, and sometimes the grandeur that can flourish through, friendship.

Max Evans

O'Keeffe and Me

Chapter One
In the Beginning

The best thing about life is the unusual people you meet. You seldom know when it will happen, or where. Sometimes you're fortunate enough to meet someone who becomes your friend. It is, however, extremely rare to get to know that someone who startles the mind and stuns the eye to such a degree that he or she is indelibly etched on your consciousness. Georgia O'Keeffe had that effect on my wife, Clara, and me. O'Keeffe was one of the world's greatest artists. Her talent was so singular that her fame still blossoms many years after her death, just as her surprising and warm friendship toward us still grows in our hearts.

This book is a memoir of that friendship, which proved one of the most cherished relationships of our lives. The woman was unique. A brilliant mind and a brilliant talent. Wise, strong but compassionate, and endowed with a keen sense of humor, she well understood the importance of laughter as tonic for the soul. She was independent and courageous, unafraid to speak her mind.

It's unlikely we ever would have met were it not for journalism, the profession I've loved and pursued since 1941, when I got a part-time job as office boy at the *Lexington Herald* in Lexington, Kentucky. The salary wasn't much, but $7.65 a week seemed a princely sum of money to the seventeen-year-old editor of the *Hi-Times,* the biweekly Henry Clay High School newspaper. In those days 50 cents would buy lunch at the White Spot Cafe.

In 1944, journalism introduced me to A. B. "Bud" Guthrie, Jr., soon to win acclaim for his novel *The Big Sky,* plus a Pulitzer for *The Way West.* It was Bud, then city editor of the *Lexington Leader,* who offered me a

full-time job as photographer, which enabled me to work my way through the University of Kentucky. Clara, a registered nurse, and I were married eleven months later. I switched to reporting in 1950. A few years later we discovered New Mexico and moved west, to Albuquerque.

Like Georgia O'Keeffe before us, we visited the place and became intoxicated with its sunshine and big sky, eyepopping landscapes, three cultures, friendly people, marvelous history and climate. I dropped by *The Albuquerque Tribune* and visited with editor Dan Burrows, who six weeks later offered me a job as reporter for $90 a week. This caused us to flee the postcard neatness of the rolling green bluegrass country for the ruggedness of the desert Southwest.

After two glorious years covering city hall, we were lured by better pay to *The St. Louis Globe-Democrat.* But our hearts remained in New Mexico. We returned "home" in 1956 after a midnight phone call from Burrows offering me the job of city editor. It was a position I relished. Because the *Trib* was an afternoon paper, I had to be on deck by 6 A.M., leaving ten to twelve hours later. I got every other Saturday off. On the odd Saturday, I worked the copy desk slot, putting out the paper.

The move to management took me away from my first loves, writing and photography. When I returned to the West, I was determined to keep my hand in those areas. So Clara and I soon began hitting New Mexico's back roads, digging up stories and pictures for the paper, plus freelance pieces for magazines. By 1962, I had begun to sell articles and photos to magazines. Naturally, I was always on the lookout for stories. I soon spotted a small newspaper item in the *Albuquerque Journal* about Georgia O'Keeffe's return home to the northern New Mexico hamlet of Abiquiu following a trip. This sent me to the public library and the *Trib*'s "morgue" files for information on the artist. The little I found was enough to pique my curiosity and convince me there was a good story there.

Actually, little had been written about O'Keeffe in recent years. Always a very private person, she apparently had become reclusive. She seemed a natural subject for *Horizon,* a handsome hardcover bimonthly published by American Heritage, so I wrote William Harlan Hale, managing editor, suggesting an illustrated profile on O'Keeffe. I did my best to sell him on my idea. I mentioned O'Keeffe's self-sufficiency. "She lives

alone in the hard and colorful Chama River country of northern New Mexico," I wrote. The rest of the letter follows:

> *Her home is on a hilltop at the little village of Abiquiu. Here she raises most of her own vegetables and fruit. She restored her home from an ancient structure part Indian, part stock shed and part crumbling adobe house.*
>
> *She displays very few of her paintings at her home. Her "treasures" are simple things such as stones and pebbles she has brought back from all over the world.*
>
> *Age has not stifled her urge to travel. She recently returned from Egypt. Last fall, Miss O'Keeffe made a 185-mile trip down the turbulent Colorado River in a rubber raft with several friends. In 1959 she took a trip around the world.*
>
> *It is most intriguing that this noted artist displays few of her own paintings in her home — yet prizes the simple beauty of a pebble.*
>
> *I wonder if you would be interested in seeing a story on Miss O'Keeffe, together with photos (black and white and 4 x 5 color transparencies)?*

Of course, I'd never even seen Georgia O'Keeffe. I wasn't certain she'd even give me an interview, in light of what I'd heard about her love of privacy. But it certainly wasn't necessary to tell Hale about that. The point was to open the door. So I simply salted my letter with details I'd picked up in my research.

As any would-be freelance writer knows, magazine editors can be impossibly slow about responding to inquiries. But this time the response came with lightning swiftness. I still have a copy of my letter, dated April 30, 1962, as well as *Horizon*'s response, dated May 2. I must have touched the right buttons. Of course, Hale didn't respond; it was Albert Bermel, a subordinate editor, who asked to see the article and pictures:

> *Dear Mr. Looney:*
>
> *Thank you for your query about Georgia O'Keeffe; we would certainly be glad of the opportunity to read your essay and to see the*

reproductions, but we cannot make any further commitment than that. We are grateful to you for thinking of us.

Sincerely yours,
Albert Bermel

I was encouraged. Now all I had to do was sell the famous recluse on the idea. So I wrote the lady, as follows:

Dear Miss O'Keeffe:

I wonder if it might be possible to arrange an interview with you sometime soon? I would like to do a story for The Tribune, also a magazine article with a number of photographs. I have been in touch with Horizon Magazine, which is interested in the story. I wonder if you might have time either Saturday, May 12, or Sunday the 13th, or on Sunday, May 20? I will enclose an envelope for your reply. Or if it is convenient for you, please call me or my wife collect at Amherst 8–5377.

Sincerely,
Ralph Looney

Now the waiting began.

My letter was mailed May 3. Considering delivery to a spot as small as Abiquiu, any day prior to May 12 or 13 would be impossible. It was. And no letter came from the artist the following week. When Friday, May 18, rolled by without response, I decided she was ignoring us. I was convinced I'd struck out.

Until the next day, that is. There it was in our mailbox: my beautiful, stamped return envelope. We could hardly wait to open it. And what a letter it was. The message practically filled a standard letter-size sheet of onion-skin paper. The handwriting was bold and firm, written with a broad pointed pen in blue ink. The capital letters alone were an inch high. It said a world about the artist.

As we were to learn later, the letter was much like O'Keeffe's life: direct, concise and simple. It contained only fourteen words. It reads as follows:

Abiquiu, N.M.
5/17/62

Dear Mr. Looney:

I will be at home Sunday morning, May 20th if you wish to come.

Sincerely,
Georgia O'Keeffe

It was exactly what one might expect from this remarkable artist who rose to fame with her bold macro paintings of flowers and stark images of bones and animal skulls. In a word, it was startling. Especially to the uninitiated, such as we. I had to wonder if such a strong personality would be difficult to interview. We were soon to find out. On Sunday morning, Clara and I headed north to Abiquiu, bursting with curiosity about the legendary lady of the letter.

Chapter Two
A Place Called Abiquiu

Most mortals seek a sanctuary to flee to when the problems of life threaten to overwhelm them. Georgia O'Keeffe found hers in a place called Abiquiu. It was an appropriate choice for a woman to whom independence was a way of life. The dusty brown village and O'Keeffe's rambling old adobe sprawl over a hilltop overlooking the irrigated valley of the Rio Chama. The valley resembles a strange green snake meandering through gray-brown desert hills. Were it not for a few power and telephone poles and assorted pickup trucks, Abiquiu could easily have passed for a seventeenth-century Spanish hamlet. It is much the same today.

Traveling north on U.S. 84, you can't miss the sprawling O'Keeffe house, which crowns the sixty-foot-high bluff that is the foundation for the village. It is brown adobe surrounded by a low wall of the same material. Large glass windows glitter in the rays of the morning sun. It is much larger than village homes, and it dominated the landscape in 1962, as it continues to do in the 1990s. Of course, its queen no longer rules there. The mansion is now the property of the Georgia O'Keeffe Foundation, which employs local men to guard it from harm.

Directly below the O'Keeffe home, in striking contrast to it at the foot of the hill, is a frame house that in better times was a restaurant; at least, a faded sign that reaches across the white clapboards still says so, as does a slightly smaller one just below it reading OPEN. A few trucks, cars and house trailers cluster nearby. The northbound highway curves gently to the right, then sharply to the left behind the bluff. To the right, across the river,

a lofty salmon-colored sandstone bluff punctures the sky. Today, Bode's General Merchandise store and gas station at the roadside supplies everything from groceries to hardware for the villagers. For $20 you may even buy a poster with a big black-and-white photograph of Georgia O'Keeffe grinning from the rear seat of a motorcycle with film actor Marjoe Gortner astride the front.

The artist certainly located the place with the best view available, a place also remote enough to please her: it is 100 miles from Albuquerque and 42 from Santa Fe.

This friendly hill has been sheltering people for centuries, its roots buried deep in the misty past when Tewa Indians built a pueblo here. The Tewas probably abandoned it sometime in the late 1500s. In 1747 the Spaniards discovered the ruins and erected a hamlet of their own atop the crumbling Tewa adobes. They called it Abiquiu (pronounced AB-ee-cue), believed to be a corruption of Tewa words. For the next ninety-nine years the village endured ups and downs, fighting off raids by Ute, Apache and Navajo Indians. As in most Spanish frontier towns of the time, the Spaniards were usually busy either trading with the Native Americans or fighting with them. When the United States claimed New Mexico in 1846, U.S. Army cavalry troops were garrisoned here to make war on roving tribal raiders.

In 1776 the hamlet enjoyed a brief flirtation with history when Fray Silvestre Velez de Escalante paused here at the beginning of a two-thousand-mile expedition to blaze a trail to Spanish settlements in California. Although he failed to reach his destination, he found routes still in use through the Great Basin.

Today, Abiquiu radiates the same brand of sleepy charm it did in 1962, like the many old Spanish hamlets still alive across northern New Mexico. The ancient plaza survives, dominated by a lovely adobe Catholic church in authentic New Mexican mission style. It is named for Saint Thomas. On the edge of town three black crosses loom atop a hill beside a Penitente *morada* (church). The secret order of the Brothers of Light arrived in New Mexico with the earliest Spanish settlers in 1598 and remain strongly ensconced. Their processions and re-enactments of Christ's crucifixion continue to this day.

This is a unique part of the Southwest, rich in history, but the land itself remains the star: raw and colorful and lonely, a timeless place of big sky and vast distance. This is challenging country that demands strength from those who choose to live here. It was, quite clearly, pure "O'Keeffe country," as we were soon to learn. And appropriately, even the morning was smiling bright sunshine against the sparkling blue sky.

Clara and I had no trouble finding her house. We knocked on the gate, its boards weathered to a mellow patina. Above the entry, the white skull of a ram, its curled horns intact, stood guard. Inside, in the patio, two big, woolly blue chows watched us sleepily.

Suddenly, O'Keeffe appeared, looking strikingly monastic in a long black wraparound dress set off by a white V-shaped collar. She also wore a black belt adorned with a hand-tooled Indian silver concha buckle that sparkled in the sunlight. Her graying hair was done up in a bun on the back of her head. She seemed surprised about something.

"That's strange," she said, puzzled. "You didn't upset the dogs. They must like you."

I got the distinct feeling we had passed a test. If the dogs endorsed us, so, maybe, would O'Keeffe. Her greeting was warm.

Her face was overwhelming. At the time, I thought she looked exactly like a tough pioneer woman marching stolidly across the plains behind a covered wagon. Her skin was tanned the rich brown of old leather, etched by countless deep wrinkles. The line of her jaw was as hard and tough as the country she called home.

But most striking were her sharp, clear eyes, quite as blue as the southwestern sky. Unblinking, they met ours, boldly challenging and bright with interest. They looked surprisingly young peering at us from that leathered face, hardly what you'd expect in a woman of seventy-four summers. They were wise eyes that literally seemed to bore into you like finely sharpened daggers, probing, questioning, demanding.

Her lips were thin and first gave an impression of sternness. But this lasted only until she smiled, the warm soft smile of a sensitive woman. Actually, the initial severity of her countenance turned out to be a mask of protection against strangers.

I will never forget her voice. She spoke softly, enunciating each sylla-ble with the crystalline clarity of a brushstroke in one of her paintings.

Immediately, I realized age had put wrinkles on her skin but not on her mind. She was alert and quick. I learned swiftly that her interests were unlimited, her curiosity boundless and her energy unrestrained. The breadth of her knowledge was startling. She could converse on virtually any subject and had an opinion on everything.

Neither Clara nor I had ever encountered a person with such presence. It was regal. She carried herself as ramrod straight as the proudest of queens, her shoulders squared with the assurance of royalty. In all the years we were to know her, we never saw her shoulders slump, even when she was seated. She radiated confidence, character and pride, and above all, will.

She led us into her house, which proved as unique as the artist. We entered through a courtyard. The house was on our left and another build-ing housing her studio, bedroom and bath was on our right. We followed the lady through a small anteroom with a large window looking into a tiny courtyard. It was a true eyestopper. The window served as a frame for the "picture" that was the small space outside, which contained a twisted, weathered tree stump set off by two patches of green grass against the sun-baked earth. Without a single tube of paint, the artist had converted the microsize space into a living three-dimensional picture.

The house at one time had been typical Spanish territorial. Now it was pure O'Keeffe. And she clearly was most proud of it. She led us on a tour, which provided our first visit to her huge studio and its giant window over-looking the valley. She talked about the house throughout, displaying her love for the place.

"I've lived here since 1949 or 1950," she said. "I'd had my eye on this place almost since I had got the house at Ghost Ranch." (She still owned that house sixteen miles north of Abiquiu and lived there in summer.) "It took years before I finally badgered the Catholic Church into selling it to me. It was empty. A ruin. They let the village pigs run in and out. Some of them slept inside the walls at night. When I bought it, it had to be roofed and floored and remodeled. With some help from a friend, I did it over." She added, "I did many things over. I didn't want it to be Spanish. I didn't

want it to be Indian. I didn't want it to be modern. I just wanted it to be my house."

She had certainly succeeded. The house was uniquely her. One of a kind. Walls, inside and out, were plastered with adobe, as were the floors. Some inside walls were painted stark white, offset by others that were the rich, natural adobe brown of the floors. Ceilings were made of small varnished sticks stripped of bark called *latillas* (pronounced la-TEE-yas). They were supported by the peeled log beams that the Spanish call *vigas*. Many skylights brought sunshine inside through the flat roof.

Frank Lloyd Wright himself couldn't have chosen more functional furniture. Couches in the long, narrow living room were *bancos,* adobe benches built up from the floor. On one of these, two white cushions rested, each emblazoned with a bright red rising sun and Japanese characters alongside their English translation: "Pray your family 10,000 happinesses." A black cushion separated the two. The most surprising thing in the room was a small, square glass-topped compartment in the banco seat. It contained a small skeleton of a rattlesnake complete with rattles, sitting coiled to strike on a piece of black velvet. "How do you like my rattler?" she laughed. "That's my prize. A friend found it for me. I think it's great fun, don't you?"

Nearby, a clay pot held a jade plant. An unusual square table made of a single inch-thick piece of plate glass sat in front of the couch. It held two books on Antarctica, with covers that were mostly blue, and a small tray with two metal grasshopper figures on the edge. An African mask hung on the wall. When I asked her where she found the grasshoppers, she smiled and said, "Oh, I just love them! I got them in Tangier."

At the end of the couch was a black table. Hanging over it was a small painting by Arthur G. Dove. A fat stack of *New York Times* papers was piled against the wall. A vase on the table contained a huge bouquet of white, lavender and yellow iris. It formed a virtual kaleidoscope of colors that dominated the room. Another enormous bouquet bursting with yellow roses added color on another table.

Simplicity was the rule in O'Keeffe's house. The living room contained four white easy chairs. Nearby was a white hassock topped with a black-and-white checked bandanna. White drapes hid the bookshelves built

into the walls. There were several inexpensive reclining chairs where the artist could be comfortable while listening to her hi-fi (she spurned television). The chairs were eminently practical, like the dining table. This was a homemade job composed of a single 4-x-8-foot piece of varnished three-quarter-inch fir plywood supported by two sawhorses. She had several other similar tables throughout the house.

A large painting hung on the wall facing the banco. The lower part was stark white blending into yellow, green and blue. I asked her what she called the picture. "Oh, I don't put names on them," she said. "I never do." When I asked why, she responded, "Why should I? Other people always put the names on my pictures — quite funny names, I think. I let them call them whatever they wish. The picture speaks for itself."

She told me she never signed her pictures. "If there is any personal quality in the picture, that will be signature enough."

O'Keeffe explained the absence of a frame on the picture. "It's pretty sad if you have to frame them," she said. "The picture should be enough. Of course, when you send them away, you have to put something on them. They have to have some way to handle them. I put a little metal frame around them when I send them off, the very least thing I can."

She said she preferred not to hang pictures, "except for a few." She gestured toward the one on the wall. "Like that. I enjoy that," she said. "But I'm rarely ever pleased with a picture I do. So I make a point of not having them up. Having a painting up is like looking at your own thoughts. It annoys me having them around. I'd rather look at a blank wall."

Her blue eyes twinkled. "Now and then, though, there'll be one I like to hang up to surprise people," she said. "It amuses me to watch their reaction. That picture is one of them."

On the other hand, she told us, she got no uneasy feeling about her pictures being on someone else's wall. "What they get out of them is something completely different than what I get out of them," she said, then paused. She smiled, her eyes twinkling. "And there are some pictures I wouldn't sell to anyone." Were there pictures she hated to part with? "I won't tell you which ones they are," she laughed. "I wouldn't flatter the people who have them by letting them know I minded."

I asked how long she worked on a painting like the one on the wall. "I do my best work when I work all day every day until I finish it," she said. "You see, I work very fast. If I don't keep after it, it is apt to be no good. When you let them go and work on them for months and months, they're never any good."

I asked if the idea of a picture occupied her mind for some time before she painted it. "Well," she said, "I'm very clear about what I want to do before I start, otherwise it's a waste of time. I must always have the whole picture in my mind before I start. Usually, I have drawings — not what you would call drawings that you could hang on a wall, but just scraps of paper with lines and shapes on them. Sometimes I write the color down. Marin [John Marin], now, makes rafts of drawings. There are just all kinds of them spread out all over the floor. I don't do that."

"What about the picture on the wall?" I asked.

"That's something that I saw," she said. "Usually, what I paint is something that I see. Actually, that picture is almost photographic. It's something I saw from the air. There was a line around the whole horizon. It was an extraordinary effect. Here was this great white field of clouds solid against the blue. I did a smaller one, but the bigger one is better. I thought for a while about doing it on the wall and just painting it completely around the room. But that would take too much time, so I settled on this one."

"Is most of your work in oil?" I asked.

"I work with oil now, almost entirely," she said. "I like pastel very much, but in this country it's much too dry. Too hard on your hands. Too much alkali to begin with."

Did she ever do watercolor anymore? "I stopped when I quit using some old cheap paper," she sighed. "I had a kind of old paper that I liked very much, but everyone told me I ought to get something better. I never found any other that I liked. So I just stopped using watercolors."

"I suppose oils take a good deal more time," I said.

"Oh, yes," she responded. "I used watercolors when I didn't have time to work with oils. I had an old table with a big drawer that went completely under it. I could pull it out on either side. I had all my colors and brushes and everything right there ready to go. With oil it was quite a different matter. I consider watercolor an easy medium."

I noted that her work ranged from abstract to semiabstract to realism and asked her to explain why.

"I'm always winging from one thing to the other," she said. "I have always been very free in my approach. I paint because I like to paint. I paint what I want to paint. I painted many abstractions before I was known at all. I still paint both ways."

"Then you don't see any reason why realistic art and abstract art can't live side by side?"

"Certainly not," she said. "What's the difference whether it's one or the other? It's the same principles that make one or the other satisfactory to you."

Was she expressing something with her painting? "I never think about expressing anything," she said. "I'm not so wonderful that my thoughts should be expressed that way. I like to be interested. And I paint what interests me. If I could be ten people, I'd keep them all running all day. I like to do things. I like to go places. Yes, I live here in rather isolated fashion, but now and then I take a trip. There are so many things to do!"

"Speaking of isolation," I said, "do you have a telephone?"

"No," she responded quickly. "That part of my life is behind me. I've never had a phone since I've been in New Mexico."

At the time, I believed her. There was no reason not to. As it turned out, she lied to me. Only comparatively recently — ten or twelve years later — did I learn that O'Keeffe had had a telephone at her Abiquiu home since the early 1950s and used it frequently to talk with her two sisters and others. Why did she tell me that white lie? The only feasible reason I can think of is that she was protecting her privacy, something that was always of major importance to her.

Chapter Three
Of Rocks, Skulls and Bones

On that sunny day in 1962 it was time for lunch, prepared by her maid, Dorothea Martinez. We seated ourselves at the plywood dining table as Dorothea prepared a hot little blaze in the round, Indian-style corner fireplace.

Dorothea was a tall Abiquiu native who went about her chores swiftly and efficiently, saying very little. She had worked for O'Keeffe for years and got along with her well. Both projected an obvious mutual respect. Her family roots in the village probably went back seven or eight generations or more, like those of most residents. Indeed, it is quite probable that a goodly number of villagers could trace their family trees back to 1598, when a Spanish conquistador, Don Juan de Oñate, led the first settlers to New Mexico. Nearly two centuries later, when the thirteen colonies were beginning the Revolutionary War against England, Spaniards were solidly ensconced in villages across northern New Mexico. The culture — and the Roman Catholic faith — they brought remains pretty much intact in isolated places like Abiquiu.

These villagers, as do inhabitants of isolated areas everywhere, tend to be somewhat suspicious and skeptical of outsiders. But most of those in Abiquiu had readily accepted O'Keeffe. They learned quickly that this Anglo was genuine, one who took great interest in them and their problems. She treated them with respect and was there when needed. She'd do anything to help a friend. It was her nature.

O'Keeffe lent a hand to many of her fellow villagers. The extent of her philanthropies will probably never be completely known, so carefully did

she preserve their secrecy. She helped village children, providing funds so they might attend school. Although many of the villagers loved, respected and protected her, others resented her presence and obvious wealth on the hilltop. As always, O'Keeffe went her own way and ignored her detractors and continued to get along fine with her village friends.

In somewhat the same way, O'Keeffe became close friends with the monks of the tiny, remote Monastery of Christ in the Desert thirteen miles up a dirt road along the lonely Rio Chama Canyon northwest of Ghost Ranch. Even though the artist admitted no religion of her own, she took a motherly interest in the Benedictine monks and occasionally attended services in their small, beautiful adobe chapel. She loved people passionately, especially those less fortunate than she.

She was interested in virtually everything, including nutrition and food. Lunch on our first Abiquiu visit consisted of an enormous salad filled with green things topped off with generous numbers of alfalfa shoots. Three or four different kinds of tasty cheeses, whole wheat bread, carrot juice and an exotic-tasting herb tea were also served. I found it delicious, but I noticed that Clara barely touched the salad. When O'Keeffe excused herself for a kitchen conference with Dorothea, I asked Clara why she wasn't eating her salad. She looked me squarely in the eye, declaring, "I am not a cow!"

Clara was referring, of course, to the alfalfa shoots, which were usually reserved for more bovine diners. Unfortunately, she hadn't seen our hostess re-enter the room. O'Keeffe grinned at Clara and said, "Mrs. Looney, you don't have to eat it if you don't want it. You're a very honest person. We're going to get along just fine." Obviously, we had passed another O'Keeffe test. We were to learn that she had tremendous respect for honesty.

We learned quickly about O'Keeffe's organic gardening. She was clearly an expert and had utilized virtually every inch of the three acres surrounding the Abiquiu house. Of course, we already had glimpsed the abundance of flowers, something we had anticipated. What else would you expect from the artist who startled the 1920s art world with her giant close-ups of flowers? But though there were plenty of floral displays around, most of the garden was planted in vegetables. O'Keeffe said she tried to grow enough to last through the sometimes harsh winters.

She loved to scour the hillsides for edible green things, a source of constant frustration to Dorothea and a delight to the artist. "She's always trying to figure out what they are," O'Keeffe chuckled. "And I don't intend to let her."

O'Keeffe was fond of watercress and told us about a spot on a nearby mountain where it grew year-round. It wasn't uncommon for her to use a team and wagon to get to it in winter.

The artist took her organic gardening very seriously, believing strongly in the importance of vitamins and minerals in her diet. She was a strong believer in nutritionist Adelle Davis and her book *Let's Cook It Right.* She boasted that she never took pills, even aspirin, and seemed to manage well without them. Her amazing vigor was excellent evidence of the soundness of organic gardening and cooking in good health.

But at the moment, I had other things on my mind. I'd been wondering all morning how O'Keeffe was going to react to picture taking. After all, this was a woman who had been exposed to several of the most expert photographers in the world. The list included her late husband, Alfred Stieglitz, as well as legends like Ansel Adams and Eliot Porter. I had to wonder whether she would deign to allow me to photograph her.

Sure enough, after lunch, when I told O'Keeffe I wanted to make some pictures of her, she bristled. She threw me a glance like some haughty schoolmarm speaking to an unruly student and declared, "Young man, I don't know what kind of pictures you take. I don't know that I want you to take my picture!"

Not quite knowing how to respond, I said nothing. Instead, I knelt and opened my camera case and extracted my old Rolleiflex and began checking to see how much unexposed film it contained. What I'd call a pregnant pause ensued — long and painful — as I fussed with the camera. Then, finally, she surrendered. "Oh, all right," she said. "Where do you want me to sit?"

Of course, I suggested her studio with its enormous window overlooking the valley of the Chama. O'Keeffe, never a shrinking violet, wasted no time in telling me she abhorred pictures of people smiling. "I can't understand why Americans always want to be photographed displaying their teeth," she grumped.

I got her message, and we got along quite well. She was an excellent model. Her patience was superb. She responded quickly to suggestions. No doubt her expertise had been gained modeling for Stieglitz over many years. She preferred to look stern and serious before the camera.

One of the photographs I shot that afternoon turned out to be O'Keeffe's favorite. I think she liked it because it showed her strength. Those sharp eyes, alert as an eagle's, were looking straight into the camera lens. The set of her jaw, the stiff shoulders, reflected a woman with complete, steely confidence in herself. This, I'm certain, was the image that O'Keeffe wanted the world to see. She liked the portrait so well she used it whenever a personal photo was needed for publicity purposes. For many years I provided her with stacks of 8-x-10-inch glossies absolutely free of charge, most of which were sent to the Downtown Gallery in New York.

Both Clara and I were convinced that day that Miss O'Keeffe (as we always addressed her) flaunted her toughness to mask what was actually a warm personality and quick sense of humor. That conviction was reinforced over the ensuing years as our friendship grew closer. The warmth shows in many other photos I made of her, many of which appear in this book.

The state of her studio that afternoon was in marked contrast to the neatness of the rest of the house. It looked as if one of our western dust devils had whipped through the room. Papers, brushes and odds and ends were strewn about, along with her canvas-stretching tools and other paraphernalia. At that moment, she seemed caught up in a dither of activity. Pictures were everywhere. She said the same was true at the other house, sixteen miles north near Ghost Ranch. When I asked about all the activity, she gestured and said, "God only knows why. It just seems there are so many things I've got to paint."

In one corner, a large canvas of some yellow daffodils was propped against the wall, half hidden by an easel. She was unhappy with it, had been working on it off and on for months.

We looked at another painting, a vertical, containing a pattern of gray, black and blue. Her inspiration was something she had seen from the air — the confluence of two desert rivers somewhere in the Middle East. She said she had become fascinated by things she had seen from the air on her

travels. "It's a totally different world when you're riding up there at thirty or forty thousand feet. You get a totally different perspective on the world."

A smaller picture was half hidden in a corner. It consisted of a brown line curving gracefully across a field of white to disappear in the upper left corner of the canvas. She led us out on the hill in front of her studio and pointed southeastward toward the distant, blue Sangre de Cristo Mountains. Instantly, I saw that what she had painted was the gently curving road. "It was in the wintertime — the valley was covered with snow, except for the brown road," she said. "An interesting effect."

I spotted an odd yellow object in the clutter on a table. I picked it up and found it to be a shiny new Geiger counter. This was the time of near panic in the United States about the threat of nuclear attack, a time when many people were digging underground shelters to protect them from radioactive fallout. When I asked what she needed that for, she smiled knowingly and said, "Who knows? I may need it one of these days to measure the fallout."

Obviously, the atomic bomb scare of the early 1960s had reached all the way to the isolated hamlet of Abiquiu, and O'Keeffe was prepared for whatever might come her way, even atomic bombs. I was reminded of a millionaire pecan grower in southern New Mexico who had told me seriously about the fleet of eight World War II B–25 bombers he had stocked with supplies in preparation for Armageddon. He had studied wind currents indicating the safest haven from fallout would be Chile. I decided not to question her further on the subject.

Mementoes of O'Keeffe's travels were placed strategically and effectively throughout the big studio. A piece of silk from India, a primitive wood carving from Africa, a hand of Buddha from Thailand. But most noticeable of all were her rocks. They were almost everywhere we looked. Outside, in front of the huge studio picture window was a table made of a sizeable chunk of sandstone covered with smooth rocks gleaming in the sun. They ranged in size from tiny pebbles to stones the size of a football. Most had one thing in common — they had been smoothed and polished by some form of erosion. We saw them in every room in the big house — sometimes a few in a glass dish, sometimes a single rock lying on a table. The studio had a plentiful supply.

Her bedroom, which was entered through a barely visible door in the white wall of the studio, displayed enough rocks to pave the patio. It was heated by a corner fireplace of Indian design. The bed was a low, starkly simple piece of furniture that was strictly functional. The room was surprisingly spartan, more like the cell of a monk than the bedchamber of a rich and famous artist. But it was powerful evidence that O'Keeffe cared little for material things.

Over the bed a shelf, running the length of the room, held rocks of all shapes and sizes. A simple reading light was attached to the headboard. A few cushions on the floor provided places where one could sit, but there was no other furniture. A beautiful quilt of iridescent silk covered the bed. She had bought the material in India and had the quilt made from it.

She noticed my curiosity about the rocks. "You're wondering about the rocks, aren't you?" she smiled. "Those are my treasures. That's why I got a house in the first place. I had to have a house to keep my treasures. There wasn't room in my apartment." She extended a hand to the windowsill, selected a particularly smooth ebony stone. She rubbed her hand across it almost lovingly. "It started when I first fell in love with this country out here," she said. "I wanted some means to keep it, to express the country. You couldn't press flowers. So at first I started picking up bones, then later on, rocks. I remember one year I sent back a whole barrel of bones to New York. The express charges came to $16 on that barrel! Later, I graduated to rocks."

Did this collecting indicate an interest in geology? She shook her head. "I don't know a thing about geology. I just pick rocks because of their shape, their smoothness, their beauty." Color meant little in her rock collecting. Her favorite was a small black stone buffed and polished by the Colorado River. Her close friend the noted photographer Eliot Porter had picked it up. Its only distinguishing characteristic was its round smoothness. To her it was finer than a rare jewel. "Eliot and I were on a raft trip on the Colorado River last year, and both of us found special rocks," she laughed. "But his was better. I kept after him the rest of the trip about wanting that rock, but he said he'd have to take it home to his wife. Then, he said, he might talk her into giving it to me. On a later visit I just picked it up off their table and brought it home. He never missed it!"

It was when we began to understand O'Keeffe's interest in the rocks and bones that we began to perceive what made her tick. She was unimpressed by material things but fascinated by nature. For example, her election to the Academy of Arts and Letters meant nothing to her. But the southwestern desert country, a place where nature is very close and very real, meant literally everything. To her, this savage land was the be-all and end-all of life. The things she cherished were simple symbols of the hard land: bones and skulls whitened by the hot yellow sun and polished by wind-blasted sand, rocks prepared by nature in the same way.

Many animal skulls were scattered around her two houses. Among them was a bison skull obtained on a hunt in the West by President Theodore Roosevelt and Gifford Pinchot and presented to her many years before. There was also a horse skull that came from the D. H. Lawrence ranch near Taos.

In many ways O'Keeffe was flint-hard, like the rocks she collected. She worshiped toughness. It pleased her when others considered her tough, and she did her best to reinforce that impression by creating a kind of shell around herself. But tempering that was a warm feminine sensitivity. I suspect it was the combination of these qualities that contributed to her greatness as an artist.

Her passion was the beauty of nature. She appropriated it as her own whenever she could. Like the rocks. Or the bleached white skulls and bones of animals. Or the awesome immensity of rolling sand and mesa and mountain visible from her patio at Ghost Ranch, as we later learned. From this vantage point, in the far distance she could see the dark and towering flat-topped shape of a 9,862-foot mountain named Cerro Pedernal. Appropriately, *pedernal* means flint in Spanish. "It's my mountain," she liked to say. Surely no one would dare deny it. She loved it, painted it, explored it. Saw the burning orange globe of the sun sink behind it day after day, kindling scarlet flames in the billowing clouds. Watched it entranced as late summer thunderheads laced with lightning bolts boiled and boomed above its bulk. Certainly she owned it, even if she never had a deed. The god she never believed in gave it to her.

Financial success meant very little to such a woman, one who saw lines and shapes and colors in rocks and bones and sandstone cliffs and distant

mountains, things less fortunate folk could not see. The considerable wealth that she acquired from her painting enabled her to be totally independent, to live as she wished, where she wished and to travel the world as she pleased. She reveled in her liberty and the power it brought her. But not totally. "Possessions are such a headache," she declared somewhat petulantly. "I've often thought how wonderful it would be to simply stand out in space and have nothing."

She claimed that she didn't consider herself ambitious. She insisted that having a show was a "great misery" to her. Yet, when I asked whether her success required self-discipline, she answered, "It's simply that you decide on the kind of person you want to be, and then you get at it. It's like a habit of neatness." When I pressed the point, asking if there wasn't some single achievement in her life of which she was most proud, she thought about it for a while. "I don't really know," she said seriously. "I don't think much about myself. I guess if there were any one thing, it would be getting the dogs to obey me. These are the first ones I've ever had that would. I guess that would be an accomplishment."

It was after four. Time had run out on us. We faced a two-hour drive home. Both Clara and I were thoroughly fascinated by this remarkable woman, who now seemed sorry to see us leave. I told her we had barely scratched the surface of the O'Keeffe story. She laughed and said that was all right and that she had no traveling plans and would be happy to see us again soon.

Two weeks later, we once again drove north to Abiquiu.

Chapter Four
Where God Is Independence

If Georgia O'Keeffe had a religion, it was individualism, pure and simple. If she knelt to any god, it had to be the god of independence. The one thing she couldn't tolerate was being told what to do. That was the clearest thing to emerge from our first meeting. In our second, I decided to try to find out how she got that way.

Her welcome was most warm that beautiful Saturday morning. Spring was very definitely in the air as we sat down in the big studio overlooking the Chama Valley. I started by asking her how she became so amazingly self-sufficient. "I'm certain I developed that in childhood," she said. "You know I was one of seven children. Each of us had his own circle of friends, his own little world. Each was self-sufficient and depended very little on the others." She said her sisters were more ambitious than she. "They wanted many things in life that never interested me."

She and her mother were quite different, O'Keeffe noted. Perhaps this is why she became such an individualist. Her mother was totally unimpressed by Georgia's abstract drawings, "but it didn't bother me a bit." She remembered that her mother often told her she couldn't do something because it just wasn't done. Or because it was too dangerous.

As a child, O'Keeffe was a daredevil, something she never got over when she grew to adulthood. In fact, she took enormous pride in her daring and her unflagging iron will. There was a large chip permanently lodged on the lady's shoulder — quite big enough to be frequently evident to others (which I'm certain pleased her enormously) — about being told what she could and could not do. "People have always been telling me I couldn't do

things," she declared, those blue eyes boring into mine. "But I found out I could usually do them anyway."

When she taught at the University of Virginia, she was warned not to take walks alone in the mornings before school. It was "dangerous." So, she said, she got up at 3 A.M. and found she could walk unhindered (and unharmed) by either felons or her overprotective friends until as late as 6. Even at her advanced age, the daredevil in her popped out often on her worldwide travels. She was most proud of months she spent in the Andes, exploring native villages quite on her own.

In the early days of her artistic career, men were always telling her she couldn't paint certain subjects reserved for males. Of course, she ignored these people and painted the subjects anyway, no doubt much better than the men ever did. Certainly her paintings were much more successful.

I had to ask what turned her into such a daredevil. "Who knows?" she smiled, those blue eyes twinkling devilishly. "Maybe it was because I was the daughter of an Irish father and a Hungarian mother." She paused, then continued. "I knew I wanted to paint pictures by the time I was twelve, but I don't really know where the idea came from. I painted very little as a child, and it was always my younger sister who was considered the talented one."

When Georgia was seventeen, she said, her parents sent her off to study art at the Chicago Art Institute and later at the Art Students League and Columbia University in New York City. In New York she studied with some of America's most prominent artists. "John Vanderpoel taught me to draw," she said. "I also had classes with William M. Chase and George Bellows." O'Keeffe still remembered what an event it was when Chase came to class. "He was very theatrical and cut quite a figure. He'd come in wearing a brown serge suit with a high silk hat, chamois-skin gloves and a carnation in his buttonhole." At the time, the young O'Keeffe had not yet found her path in art. "I was taught to paint like Chase, who painted like John Singer Sargent," she said. "They painted with dash and go, using bold splashy brushstrokes. Chase had us paint a new picture every day. Then we'd have to paint over it."

Didn't she believe in what she was being taught? "I didn't know what I wanted to do then," she said. "Nobody knows at twenty. It would be easier

at twenty now to find your direction. But you must realize that this was a moment of great change in the art world." She didn't try to paint any differently, she said. "If you study with anyone, you try to do what they're trying to teach you."

Chase was pleased with her work. She was made monitor of the class, an honor reserved for the best pupil. "Chase was quite interested in me," O'Keeffe said. "I won the best pupil prize for the best painting," she recalled. "It may still be hanging somewhere around the League. It was a picture of a copper pot with a dead rabbit in it." That year, she remembered, she also took a portrait class along with five or six other students under the famed Bellows. "People always wanted to paint me," she said.

After completing her studies, she took a job doing artwork for an advertising agency in Chicago, which was a howling mistake. "It was appalling!" she cried. "I pretty soon found out I wasn't cut out for that. I suppose I could have plugged away at it and made a living. You know, that's where I learned to hurry. The idea was to do it faster, or you didn't get the job. Maybe that's why I push everybody around today."

Then, she said, quite by accident she was rescued. She got a job as supervisor of art in the Amarillo, Texas, public schools. There, at first, she had "a wonderful time." She laughed about it. "The classes were so crowded they could never find out how little I really knew, so I avoided the other teachers socially. I didn't want them to find out how little I knew."

It was here that O'Keeffe's rugged individualism began to assert itself. During that first year at Amarillo, O'Keeffe decided a Prang drawing book required for students was "utterly useless. It was completely dead, of absolutely no use to anyone," she said. "They had a bunch of poor kids in school who couldn't afford to buy that book. So I began to work out a way to teach the kids without using it."

The artist managed to convince the superintendent to stop purchasing the book. But the next year he balked. "He told me I'd have to have the kids buy them," she said. "I told him, 'Sorry, we won't.' We wound up in horrible fights over it. It went that way the rest of the year. He'd ask me if I'd ordered it. I said I wouldn't." And she never surrendered. "Finally," she said, "he sent around orders to the schools to order it, but I went to every school and got them to put it off."

Eventually, worn out by the battle, she quit to return to school at Columbia University. O'Keeffe, however, had the last laugh in that fight. She was asked to return to Amarillo the following fall; the superintendent was not. But O'Keeffe declined the invitation.

"I hadn't painted at all at Amarillo, but at Columbia I started again," she said. "For a while, I became interested in impressionism." By this time a new idea of art, fathered by faculty member Arthur Dow, was in vogue at Columbia. "The idea of clever tricks with a paintbrush was passé," she said. "Now the idea was to 'fill a space in a beautiful way.' I studied the new ideas and worked out color in the new way with shadows and light effects. Eventually, I had some difficulty breaking away from the impressionist influence."

During the summer of 1912, the artist taught at the University of Virginia, where her Columbia instructor Allen Bement also taught. "He was my best teacher, not because of his painting instruction," she said, "but because I learned much from him. The things I should read, the music I should listen to. I'm grateful to him for that, but his advice about painting was bad."

"Why?" I asked.

"He was too timid," the bold O'Keeffe declared. "He thought I should follow traditional forms and never approved of my methods of painting — the same methods that succeeded. We disagreed frequently. Occasionally, he would speak to my art class at Virginia. If I disagreed, as I often did, I got up immediately afterward and told the students I disagreed."

In the fall of 1915, O'Keeffe got a job teaching at a girls' school in Columbia, South Carolina. Now, at last, the young artist had a room of her own large enough to work in. "By then," she said, "I'd gotten a lot of new ideas and was crazy to get off in a corner and try them out." She told me she had no idea from whence those ideas sprang. "Of course, I'd seen exhibitions of modern art — there was so much unrest," she remembered. "But I missed the famous Armory Show of 1913, where the radical new methods caused so much controversy."

But she did see several shows at a gallery called 291, run by Alfred Stieglitz, a photographer. Stieglitz was the leading champion of modern art in the United States and had introduced the work of Matisse, Picasso,

Toulouse-Lautrec and many other painters. O'Keeffe remembered that in 1908 she saw Stieglitz's first showing of drawings by the sculptor Rodin. "They made no sense to me," she said. "They were very beautiful but really just a lot of little scribbles to me. This was because of what I was being taught."

She was unimpressed by modern art by two other artists — John Marin, considered by many to be a genius, and Pablo Picasso. O'Keeffe thought Marin's abstractions were "weird." She remembered wondering if "anyone could make a living doing anything like that." The works interested her, but "only like being interested in a foreign language."

In the fall of 1915 in South Carolina, the young teacher had new ideas she was eager to try. She was quick to take advantage of her expanded living space. "I decided that I'd have a little show, just for myself," she chuckled. "I spread all my pictures about the room and looked at each one very carefully. All at once I realized there wasn't a single one of them that was really me. Every picture was painted the way someone else thought it should be painted." Carefully, she put them all safely away. "I decided I'd paint some of the things I'd had in my head for so long — and I'd do them in black and white," she remembered. "I'd wait to use colors until I had something that had to have color in it."

O'Keeffe had declared her artistic independence. She would never look back. Soon afterward, she took a job as head of the art department of the West Texas State Normal School at Canyon, about twenty miles south of Amarillo. In the privacy of her room, the young teacher began creating strange abstract charcoal drawings, something totally different from anything she had ever done before. She painted things she had seen, but in a strange way. As she explained it, "I have the kind of mind that transfers experience into shapes and colors."

When I asked what she painted once she had decided to paint as she wanted, she responded, "As I told you, I had made up my mind to work only in black and white until something had to have a color in it. Then I started using watercolor. I started painting things I had seen in Texas. Things like the evening star, cattle in a pen lowing in the night. I remember I'd go out to Palo Duro Canyon and make little drawings, then I'd come home and paint them. I'd do portraits of friends — abstracts. I'd transfer

experience into shapes — shapes and colors. Sometimes I'd make ten or fifteen."

"Were they watercolors?" I asked.

"I believe I only did two oils then because it took so much time. Some of the pictures were something I made out of shadows on the wall (which were wonderful to me!), the sun back of a red cliff. While I was there, we went to Colorado, and I remember I painted a church that stood out at the town of Ward on the side of the mountains."

Finally, when she had a number of drawings, she sent them to a friend at Columbia University to let her know what she was doing. "I asked her not to show the drawings to anyone," O'Keeffe said. But of course the friend ignored the request and took them to Stieglitz. His excitement erupted like Vesuvius. "At last!" he shouted. "A woman. On paper!" Without telling O'Keeffe, he exhibited the drawings at 291.

"The first I knew of it was when someone saw it in the paper and told me," O'Keeffe remembered. "They even had my name wrong. They listed me as Virginia. I was furious! I thought, The nerve of that man! Those drawings were strictly a private matter, which no one else would understand. I tried to get the showing stopped," she smiled, adding, "but nobody pushed Stieglitz around." Once her anger cooled, O'Keeffe came to feel flattered to have her pictures shown at 291. "I don't think I would have taken my own work there."

The O'Keeffe drawings proved an overnight sensation in New York. But the artist said they also drew criticism from conservatives who objected to the artistic upheaval then under way. Unruffled, O'Keeffe continued her teaching in Texas. She spent her free hours painting.

It was World War I that caused the artist to leave her job at the Normal School at Canyon. Her sensitive nature could not tolerate the sight of young farm boys being swept from the classroom into the maw of war. O'Keeffe said most of those at Canyon came from ranches in the Texas Panhandle. Most had to work six months to earn enough money to attend school for two terms. "They didn't know a thing about the world outside," she said with passion. "And before they could barely get started learning, they asked them to go out and kill people!" She shook her head at the memory. "If only they could have given us a few weeks to teach them something about

the world they would encounter. Why, they didn't even know what they were fighting for. I asked them. 'Oh,' they'd say, 'I suppose for the women and children in Belgium.'"

The compassionate, liberal O'Keeffe gave up her job and returned to New York City in 1918 to paint. Encouraged by Stieglitz while still teaching at Canyon, she had produced other pictures in this strange new style. These had been exhibited in 1917 at 291.

I asked her what happened to the paintings she did at Canyon. "Well," she smiled, "I left them at Canyon in a barrel. When I moved to New York, I sent for the barrel, then tossed all but one into the trash. I had an apartment on Fifty-ninth Street off Park Avenue, and I'll never forget looking out the window and seeing those torn pictures being blown away from that trash can. That was finished," she said. "I had no interest in them."

She didn't know why she had saved one still life of a little toy dog and wasn't sure she still had it in the 1960s.

So perished the early Georgia O'Keeffe, the shreds of her art whisked away on the evening wind. Now she became one of the group of modern artists associated with Stieglitz. "It's very nice to have someone interested in what you do," she said thoughtfully. "And at the time Stieglitz showed my drawings, no one else in New York showed that kind of thing."

But there were obstacles. "Many people objected to me in the beginning because I didn't fit into tradition," she recalled. "My painting is a little odd, although it's not odd for me. In those days you had to be a follower."

She remembered one old critic on *The New York Tribune,* a conservative. "He'd always come by and kiss me before he wrote a review which would roast me," she laughed. "But he'd always make an effort to be as kind as he could." On the whole, however, she said the press critics gave her very good reviews. "Sometimes," she said, "in the beginning, the critics neglected me. But generally, the principal barbs were hurled by other painters."

She said her sex was another handicap. "Men in that day didn't want women painting," she said. "The painters and the art patrons figured it was strictly a man's world." Often, she remembered, patrons would ask Stieglitz to arrange an art show, then add, "And I don't want any goddamned women!" Stieglitz always insisted on showing O'Keeffe's work.

Typical of the reactions she said she faced because of her sex was the one she got when she started painting pictures of New York City buildings. "The men [whom she flatly refused to identify] decided they didn't want me to paint New York." At one exhibition in the 1920s she found a perfect spot in which to hang one of her new pictures of New York. She said, "They wouldn't let me! They told me, 'Leave New York to the men.' I was furious! The nerve of them!" The following year the indomitable O'Keeffe tried again. She succeeded in getting the picture hung. "It was sold on the very first day of the show, the very first picture sold," she declared with satisfaction. "From then on they let me paint New York."

O'Keeffe was a peculiarly American phenomenon in a day when American culture was struggling to break its ties to Europe. A reaction had set in to the long-held opinion that the only "good" art originated in Europe. At that time an artist hadn't "arrived" in America until he (or she) had at least been to Paris. This thin-lipped little teacher from the nation's midsection burst on the art scene like a brilliant ray of sunshine after a stormy night.

The woman painted flowers like no one else had ever painted them before. She examined them closely, then enlarged them to giant size and explored their innermost secrets. The colors were magnified, like the flowers, until they almost seemed to glow. Some compared her floral pictures to the Chinese and Japanese preoccupation with the character of flowers. These were bold paintings, put on canvas and paper with flawless technique. Other paintings followed. There were the abstractions — beautiful blendings of color and design — the New York buildings, plants and leaves, houses and then the stark arid countryside of New Mexico, with bones and skulls bleaching in the furnace of the sun.

Throughout her career, particularly in those early years, someone always was reading hidden meanings into her pictures. It was almost as if viewers felt there had to be some hidden explanation for such flashes of inspiration. Men wrote knowingly that the O'Keeffe flowers were symbols for sex. O'Keeffe thought that was hilarious. "People are always trying to read something into my pictures that isn't there," she laughed.

She told me about a picture she'd painted four years earlier at her house at Ghost Ranch. She wanted to paint a picture of Pedernal, the

mountain with the slanted flat top visible from her patio. The mountain was always one of her favorite subjects. This depiction was done when the moon was full and "the sky looked green." She said a ladder was always leaning against the ranch house portal. "I'd always wanted to paint that ladder, so I painted it into the picture against the green sky and the full moon." It was surely a strange painting. There's the ladder hanging out there in space, floating against the green sky. She laughed. "They tried to make all kinds of things out of that one. It was said to be a ladder to the moon or a stairway to the stars or something. Actually, I just wanted to put that ladder in it. It didn't mean a thing. Really, I have a very simple mind."

O'Keeffe also told us of how she happened to paint the famous picture of the horse skull and the pink rose. The skull came from her barrel of bones that she had sent back east from New Mexico. "At that time, you could buy artificial flowers in all the little towns out here," she said. "Oh, they were beautiful things, so simple, made from cloth. The pink rose was one of them. I had painted the skull before, and I remember standing in the apartment in New York thinking I had better do something with it before it gets beaten up. Just then, someone rang the doorbell. I was in a hurry, so I just stuck the rose in the eye of the horse as I passed the table. Afterward, I noticed — why, look what I have here — a painting!"

O'Keeffe talked freely of her dedication to the work ethic. "I've struggled every day in my life. I've worked hard. You could have no idea about how much work it is to get a canvas ready without help.

"My older brother was the favorite in the family, and we always disagreed," she continued. "Men have always told me I couldn't paint, and when I'd look over their work, I'd say to myself, 'I can paint as good as you.' It sounds egotistical but it wasn't. I don't believe I've ever had vanity. I was never vain. But I don't think I ever underrate myself either."

"I didn't ever think I'd make my living as a painter," she said. "But I sold a drawing in my second show [in 1921]. And from the third show, I've made my living from it every year. So many painters are so afraid they can't that they can't." But even after selling her first work, she never conceived that painting would be her livelihood. "Why, I didn't cash the first check I got for weeks," she said. "It seemed silly to get paid for doing something I enjoyed so much."

Looking back, she stated, "I have never had a fear I couldn't make a living. I could always teach. I could even scrub floors if necessary. I've always lived within my means. It's wonderful, of course, to be able to make your living at something you enjoy doing so much.

She admitted it had been difficult, but not in the usual sense. "It's a struggle to grind around and get ideas," she said. "Sure, I get some queer ideas, but what's the difference? I may paint a picture and get roasted. This time they'll say, 'Look at what she's done now. She'd better quit.'"

Again, she insisted she had no ambition for fame or greatness and described herself as "a curiosity — an American painting something new in a day when everyone was looking for some great new creative surge in America that was strictly American." O'Keeffe's sense of publicity told her she wouldn't have gone over nearly so well in those early days if she had shown every year. She said she always advised young painters to wait until they had "lots of pictures and could have a truly big show."

She said one of the worst experiences she'd ever had was disposing of the Stieglitz estate. "The will provided that I could have kept it all [the art collection] and sold part of it in case of need," she said. "Otherwise, I was to get rid of it all right away. That was a mountain of iron around my neck for three years." She shook her head and gestured. "I had to get rid of some four hundred pieces of art — paintings and sculpture. Everyone hated me for it. You see, I could determine arbitrarily where their work was to go. It was up to me. I could do with it what I wanted. The first group went to the Metropolitan Museum of Art, the second to the Chicago Art Institute, and the third to Fisk University."

When I asked O'Keeffe whether she had kept any part of the estate, she frowned and said, "Of course not. I never wanted any part of his estate. It was his." She placed particular emphasis on the word *his,* obviously wishing to make it perfectly clear that she wanted nothing to do with any of Stieglitz's property. It was another indication of the artist's colossal independence. She had spent a lifetime making do for herself without asking anyone for help. She took great pride in the fact that she had made her living with her painting since her 1921 show. In an era of "gimme this" and "gimme that" when lawyers are retained to advise on the smallest whim

and success is often sought by shortcut, her attitude was refreshing indeed. Old fashioned, probably. But definitely inspirational.

She gave Stieglitz credit for making sure her work was kept in the limelight. Her eyes grew soft when she talked about those years. She and Stieglitz were married in 1924. "He had a marvelous sense of publicity," she said. "He worked hard at getting me noticed. He even had portfolios made and carried them around with him, showing them to anyone who would look. He was a conservative and yet very modern. The two things side by side." She continued, "He was a person who thought aloud. He'd make statements, very positive statements, at different times of the day that were completely opposite. Someone would hear him while he was thinking out loud and report that, when he'd already changed his mind within a few hours."

When I observed that he must have been enthusiastic about her painting, she smiled and said, "He thought it was something in an odd way. I remember when I started doing my big flowers. He stood and laughed, 'But I don't know how you're going to get away with anything like that!' He was a very inspirational person."

O'Keeffe told me Stieglitz was very good at publicity and taught her much about it. He was also "very good theater," she said. "He always made a big impression. People always stopped to look at him because he wore a cape."

I asked her if she thought photography was an art. "Of course," she replied. "This is what Stieglitz battled for for years. Many people think photography is realistic. I think it lies. I am often astonished to see something after I have seen a photograph of it. Often it isn't accurate. It can be quite a bit different from the real thing. Yet, many people believe a photograph the same way they do something they read in the newspapers. And you really can't believe all you read in newspapers. We have such faith in gadgets in America, like the camera, the vacuum cleaner. But they don't always work."

Did she take pictures? "Stieglitz used to say I knew less about photography than anybody he ever knew," she said. "Yet, he'd trust my judgment of a print. I have a little camera — a Leica a friend found for me — but I haven't learned to use it. I never have the time. I've been wanting to photograph the dogs, and I haven't got around to it."

Did she have any feelings about the state of modern art? "I wouldn't say my opinion would be of any interest because you have to be in the city to know what's going on. But I was a little surprised when I walked into the Museum of Modern Art a while back and saw a lot of pieces of old automobiles pressed in a shape. They called it sculpture."

Was there was much phony art? "Youth is always considered phony," she said. "You know, young people today are seeing a completely different world than we did. Do you travel much by air?" When I said yes, she replied, "Then you know what I mean. Why, it's a whole new world opening up. They're seeing something altogether different."

What did she think of the view that the old masters are junk? "Why, I think it's absurd! Don't you? This is just a different time. We'll soon be old hat too."

Finally, I got around to asking a key question. "You have been called the foremost woman painter in the world — what's your reaction to that?"

"I think that's entirely a matter of taste. A matter of opinion. Of course, I think so," she laughed. "I don't think certain kinds of people you can compare. My painting is a little odd. Of course, it isn't odd to me. But maybe odd when you see it next to others. I don't fit in with tradition. Others have said that, and I rather agreed with them."

When Clara and I left, she again invited us to return soon. "I'm going to move up to the ranch next week for the summer," she said. "I want you to see it." We were pleased and immediately began planning another trip north.

Chapter Five
A Place Where You Can Hear the Wind

Back in Albuquerque, the first order of business was to complete the O'Keeffe article and mail it to Albert Bermel at *Horizon,* which I did, knowing full well it might be months before I heard from him. I mailed the manuscript in early June. It took until August to get a reply. "Regretfully," the article didn't meet their requirements because it lacked a critical look at the artist's work. However, Bermel spoke highly of the article and seemed genuinely sorry about this, which said something. Anyone who has freelanced knows the disappointment of receiving a small slip of paper containing a printed form rejection. But freelancing is basically a try-and-try-again pursuit, and I was convinced the O'Keeffe story would eventually sell, as it did a year later to a magazine of considerable prestige.

Clara and I accepted the artist's invitation that summer of '62 to visit her desert refuge from the world. It was some sixteen miles north of Abiquiu in Ghost Ranch country, which some consider the most spectacular scenic wonder in a unique state. It is typical Southwest high desert — dry, rocky, rugged country of soaring hills and cliffs alive with color. It was, in a word, spectacular. And of course pure O'Keeffe.

Her eight-room house would have matched the spread in a Zane Grey novel or a John Wayne western film. All that was missing was a cowboy on horseback. It was a U-shaped adobe with protruding log roof beams. Like other houses of its type, it seemed to crouch closely against the land, clutching it tightly for refuge from the searing sun. It was built around a patio in which tumbleweed and desert plants flourished unfettered and bones and skulls and rocks were burnished by the

sun. The place commanded a fantastic view of soaring scarlet sandstone cliffs, rolling pastel hills and in the distance her tilt-top mountain called Pedernal.

It was here where we sensed this woman's affinity for the land. She was as much at home in this hard and colorful country as the sharp-eyed hawk wheeling free against the crisp cerulean sky. The union of artist and country was firmly fixed; the raw land and its symbols were inextricably linked with her pictures.

The artist had her first exposure to New Mexico in 1917 when she was teaching at West Texas State Normal School. It was a brief visit, but quite enough to bring her back to Santa Fe and Taos in 1929. "From then on," she told us, "I was always coming back. I was totally overwhelmed. The color! The grandeur! The isolation!" It stimulated her to produce some of her best work. It was not until 1934 that she found Ghost Ranch and was permanently hooked.

She embraced this land and its kaleidoscope of reds and russets, yellows, browns, whites and blacks. Some might even say she loved it because it was so much like the artist, tough and strong and eager for challenge, demanding and lonely. There were bleached bones aplenty to be found among the cacti and sagebrush and rattlesnakes, which delighted the artist as much as candy would please a child. Dinosaurs had even roamed this territory 175 million years ago and left their fossilized infrastructures to prove it.

In the beginning, the artist stayed at the dude ranch opened a few years earlier by Arthur Pack, a wealthy New Jersey man, and avoided the dudes she found impossible. A few years later, she found all the ranch's dude quarters occupied, and Pack put her up at the U-shaped adobe a couple of miles north and well out of sight of ranch headquarters. Even the name was perfect, "El Rancho de los Burros."

In 1940, she bought the house from Pack, the first home she had ever owned. It was almost theatrically situated, backdropped by a curtain of lofty red, yellow and white cliffs. She remodeled it to welcome the sun into the interior, providing picture windows throughout and glass walls on two sides of her bedroom. She also had a wall knocked out between two rooms to make a spacious studio.

Georgia O'Keeffe had found home in "El Rancho de los Burros." She preferred it to the Abiquiu house to the end of her life. She only retreated to Abiquiu for the fall and winter months.

In 1955, Pack gave twenty thousand acres of Ghost Ranch to the Presbyterian Church, including ranch headquarters and a number of buildings. The new director, Jim Hall, became O'Keeffe's good friend. She introduced us to Hall on a visit to the ranch in the late sixties. He was a rugged, soft-spoken man who seemed to be as much in love with the country as O'Keeffe. When fire swept through the main ranch headquarters in 1983, O'Keeffe presented Hall with a check for $50,000 for rebuilding.

I'll never forget that afternoon in 1962. After lunch, O'Keeffe sat there by the windowsill in her ranch house living room, talking and idly arranging her little rock treasures in two parallel lines. She was as relaxed as I had ever seen her. Perfectly at home. Serene. Happy, surrounded by the hard country. She started talking about her family and those vanished bygone days in Sun Prairie, Wisconsin. "I was one of a large family," she said. "We grew up being self-sufficient. You had to be — it was just natural. Each of us had her own circle of friends, and we never associated much with each other's friends."

She looked toward the red cliffs. "Not everybody could live out alone like this, but I like it. I prefer being alone. There aren't many people I like to talk to. I can get more done. I just can't work with someone talking to me. I imagine many people would find this kind of country offensive and even useless," she said thoughtfully. "But to me it's wonderful. I'll never live anywhere else. This is a place you can hear the wind. I love to listen to the wind."

"But you like to travel, don't you?" I asked.

She looked at me, her eyes sparkling with enthusiasm. "I love it!" she said. "I only wish I had started traveling earlier in life."

"Some years ago I was determined to see the ruins of Petra, south of Jerusalem," she said. "At the time, the place wasn't on the tourist trails. So I chartered a plane and went part way, then took a car, switched to horseback and finally walked. I wound up sleeping in a cave. It was wonderful!"

She went on to tell us about a trip to South America when she visited Machu Picchu, the "lost" Inca city high in the Andes. "When I returned to

Lima, someone told me I really hadn't seen the high Andes at all," she said. "So I returned to the back country and spent three months prowling through high country villages. It was great fun!"

She loved to camp out, using her Volkswagen microbus as a sleeper on painting trips. For other travel she used a Lincoln Continental, which was her joy. She used it to go to Santa Fe or Albuquerque when she needed to jet to New York or elsewhere. She said the VW microbus was "quite an improvement" over the Model T Fords she wheeled around northern New Mexico in the 1930s over unpaved roads.

All her active life, O'Keeffe asserted her independence, refusing to fit into a mold. She did as she pleased, taking on any challenge that presented itself. Her wide-ranging mind was reflected in her pictures. Like her, they rejected any pattern, ranging from completely nonobjective to the almost photographic. Independence to her was a way of life. When she said, "I paint what I want to paint," she meant it.

She treasured her privacy and built herself a reputation as a kind of recluse who avoided contact with strangers. I became convinced that this was done with careful premeditation so she could live untroubled by curiosity seekers and call her time her own. This, I'm also certain, had become part of the O'Keeffe image of aloofness, one she wholeheartedly encouraged. It was part of the wall she built around herself to maintain her privacy. She had created this image of being different as part of a very carefully crafted plan to become recognized as one of the world's leading artists. But she would never have admitted it to anyone.

One aspect of the image probably included her choice of clothing. She favored long, black monastic dresses, usually simple wraparounds, with white collars and silver concha belts. Or, especially when traveling, men's black suits she had tailored in New York. How much of that was image versus comfort and preference, I can't say. She did tell us she preferred to wear men's suits when she traveled because they were so comfortable and simple. The black-and-white dresses and men's clothing made her rather slight form stand out in a singular way, especially in a crowd. In a very real sense it became O'Keeffe's trademark.

This is not to diminish in the slightest her enormous talent and skill. When she said she was good at "publicity," that was the purest truth. This

wonderful woman learned very quickly how to gain maximum attention for both herself and her work. She painted pictures that were different, always startling, and always magnificently painted. She captured attention by doing the unexpected. And thoroughly enjoyed doing so.

Her sense of humor stayed as sharp as a well-honed razor and softened her considerable ego. I once showed her an unpublished article I had written that referred to her reputation as "America's greatest woman artist." She smiled, crossed out "woman" with a pen, and handed it back to me, still smiling.

Throughout the remainder of the 1960s, Clara and I spent much time with the artist, whose energy never seemed to diminish. We made many trips to Abiquiu and Ghost Ranch, enjoying every minute.

In 1963, we received our first Christmas card from the lady. Like everything else she did, this was a production. We still have it, a reproduction of a painting she had done in 1917, dubbed (by someone else) *Starlight Night.* The card was only slightly smaller than the original 9-x-12-inch watercolor, a semiabstract of varying shades of blue against a tan background. Inside was "Greetings!," handwritten and signed, "G.Ok." A year or so later, we received another card, 5¾ x 7½ inches with a reproduction of her beautiful 1946 oil, *Black Bird with Snow-Covered Hills.* The "Season's Greetings" was printed inside in four languages with a note, "My first Xmas card," and the date, January 17. Unfortunately, only a few of her letters and notes have survived the years and moving vans.

We paid a few other visits to the artist in the fall of 1962, and I was still holding off on submitting the O'Keeffe article to another magazine, more or less biding my time. The right time came in the summer of 1963. That July, Clara and I took a week's vacation, I from my newspaper work and Clara from her R.N. post at an Albuquerque hospital. I signed up for a writer's conference at the University of Colorado in Boulder. Providence smiled. As it turned out, one of America's top editors was among conference staff members. This was a real break. He was Edward A. Weeks, editor-in-chief of *The Atlantic Monthly* for twenty-five years and a subordinate editor for twelve years prior to that.

Weeks was a legend in literary circles. He was the editor who got *The Atlantic* to publish Ernest Hemingway's short story "Fifty Grand" in 1927,

the writer's first magazine publication. While heading the Atlantic Monthly Press, he published such best-sellers as *Drums Along the Mohawk, Mutiny on the Bounty,* and *Goodbye, Mr. Chips.* Weeks also had authored ten books and was only *The Atlantic*'s ninth editor since James Russell Lowell founded it in 1857.

As any freelancer would do, I went prepared. I came to class with a copy of my O'Keeffe article in my briefcase. And when the opportunity arose, the manuscript was readily available. Bingo! Weeks liked it. In fact, he called it "exceptional." Even better, he said he'd like to consider it for *The Atlantic*. He wanted to see more photographs and more elaboration on some points.

Back home the following Sunday, I wrote O'Keeffe to tell her about Weeks and *The Atlantic* and set up an appointment for the following Thursday. I got no response, but Clara and I drove up to Abiquiu anyway on the appointed day. She was ready for us. Her welcome was warm, as usual. She had even had Dorothea prepare lunch. I presented her with pictures we had taken on previous visits, and she was most grateful. She especially liked the 16-x-20-inch print I'd made of the picture she liked so much. It was a pleasant visit. She even invited us to return and spend the night.

Meanwhile, Weeks asked for greater detail in the article on O'Keeffe's early teaching and painting, plus various other items, all of which I quickly provided. I next heard from Weeks in early August. I heard nothing more from him until late November. He explained that he'd been so "hard driven what with our Special Supplement on Berlin and the equally exacting build up for January" that he hadn't been able to complete editing my O'Keeffe piece.

"We do want it for *The Atlantic*," he wrote, "probably for publication in the late spring, and I am grateful to you for the additional information which helps to fill out the beginning." Weeks noted, "The lady is still much more elusive about this phase of her career than she is about the present, and I should be happy if you could go back to her with our retyped and somewhat condensed version of what you have written in the hope that when she sees it she may be willing to expand further about her apprenticeship." His sixty-one-word sentence certainly got the message across.

In December, I wrote to O'Keeffe at Abiquiu:

Dear Miss O'Keeffe:

At last I have heard from Edward Weeks. . . . The Atlantic Monthly plans to use the article on you probably in the late spring. I shall see that you get a copy.

I have also printed a few more 8x10s for you which I'll enclose. There are more, which I'll send or bring to you later. Again, I'd appreciate it if you didn't use them for publication until I find out what photographs Mr. Weeks intends using.

I do hope we can get up to Abiquiu sometime this winter to see you. I would like to try again to get some better photographs of the paintings for you. As I told you, I was not at all satisfied with the others.

Sincerely,
Ralph

In January 1964, I took the manuscript to Abiquiu for O'Keeffe to read and try to answer some of Weeks's questions. She liked most of it but went off like a skyrocket when she saw the prices her artwork was fetching, which I had obtained from the Downtown Gallery in New York. "Why are you putting these prices in here?" she asked, frowning. "There is no sense to running them, and I want them omitted from the article!"

Suddenly, O'Keeffe had become imperious, exposing her rock-hard will. When I told her Weeks had asked for the prices, she said, "Oh, he did, did he. Well, I don't want them and they're not going to appear in the article." She continued to look me straight in the eye and said, "If anyone's interested, they can ask, and anyway, I've gotten much, much more than the top figure the Downtown Gallery gave you!" She paused, her lip curled, and added, "Much more! And you can tell Mr. Weeks that. No prices."

The gallery had told me O'Keeffe's small pictures ranged from $3,500 up, with her largest paintings going for $15,000. Not bad for those days. In a few years, those prices were to soar into the hundreds of thousands of dollars and move (in her lifetime) to more than $1 million.

O'Keeffe, still upset, then declared, "I'm conceited enough to know what pictures I paint will sell. If a picture doesn't sell now, it will sell in two or three years. I did a painting three or four years ago that no one was interested in. In recent months three people have expressed interest in that picture. Each time, the price goes up, and I don't know what price I'll finally ask — and get — for it."

The artist was also totally unwilling to explore those early years for *The Atlantic.* "The fact is," she said, "no matter what Mr. Weeks may think, I neither sought nor particularly wanted success." She went on to say, "The success I've had has come from a strange combination of luck and my rather odd ability to paint pictures people would buy. I think my lack of ambition actually contributed to my success simply because I never worried about being unable to make my living at it."

Oddly enough, I think the incident over the prices turned O'Keeffe against Weeks. I never heard her mention him again. As far as the dispute was concerned, O'Keeffe ruled. The published story said only that her work sold for "large sums." The illustrated article didn't appear in *The Atlantic* until the April 1965 issue, fourteen months later. I was paid in December 1963. The delay may have been caused by an oversupply of more timely material, what with the Cold War heating up. But fourteen months?

I've always wondered whether it was a case of a strong editor used to getting his way getting back at a strong-willed Georgia O'Keeffe for refusing to reveal her prices. He may also have been miffed that he couldn't get her to confess that she was ambitious and had sought success. If she was and had, as I believe, she wasn't about to admit it. After all, she'd spent a lifetime building her image. And had certainly been extremely successful in doing so.

Our own relationship with the artist continued on its warm basis. She was a marvelous conversationalist. She spent much time reading. We talked about many things, even, at times, politics. She was an unreconstructed liberal who thought President John F. Kennedy was tremendous. She was shocked and hurt when he was assassinated. She delighted in needling me, calling me an archconservative. However, I wasn't about to accept those

shots lying down. I remember needling back in some of those bouts, asking how a liberal like her ever became such a rugged individualist and so self-reliant. She just blinked and laughed.

She took great interest in my career and asked what I wanted to do with it. I told her I wanted to be a good writer and "maybe write the great American novel." And then she literally floored me. "Why don't you and Mrs. Looney [she always addressed us as 'Mr.' and 'Mrs.'] come up here and live?" she asked. "You could live at the ranch and write the great American novel or whatever you pleased."

I couldn't believe my ears. Clara was as surprised as I was. O'Keeffe was smiling and looking straight — and quizzically — into my eyes. There was a long, somewhat uncomfortable pause. "You'd be perfectly free to write, and I'd be happy to have you here," she said.

"That's the best offer I've ever had, Miss O'Keeffe," I said. "And I thank you. But I couldn't do that in a million years."

"Why?" she asked. "It would give you the chance you need."

"I know," I told her. "But I couldn't do it. I'm not made that way. I guess I'm a lot like you. It's been a kind of fetish with me to stand on my own two feet and earn my own living. My independence means as much to me as yours does to you. I just couldn't be beholden to anyone. Newspapering is my career."

"I understand," she said. "But the offer stands. Think it over."

O'Keeffe never mentioned her offer again, nor did we. It was simply an impossibility for Clara and me. There may have been times before this that I had thought of making a living with writing and photography. But now I had become committed to newspapering. As it turned out, we did the right thing. My career eventually led to my appointment as editor of *The Albuquerque Tribune* for nearly eight years, and later as editor of the *Rocky Mountain News* in Denver for nearly nine. I had the great satisfaction of seeing the *Rocky*'s circulation soar to enormous numbers and seize the lead as Colorado's number one paper. I've never regretted following this path.

We continued to be fascinated by O'Keeffe, especially by her amazing artistic activity. Every time we'd see her, she'd be working on new paintings almost as if she were driven, and something new about her own personality would be revealed to us.

Her energy was remarkable and unrelenting for a woman of her age. Maybe my opinion was influenced by the difference in our ages. When we first met O'Keeffe in 1962, she was seventy-four and I was thirty-eight. Even today, thirty-odd years later, I still find her energy nothing short of astounding.

For example, in 1965 the indefatigable artist painted the largest picture of her career, a monster oil of dumpling-shaped clouds against a blue background. It was mural-size, 24 x 8 feet. It was the crown jewel in a collection of ninety-four of her pictures hung in "Georgia O'Keeffe — 1966," a show at the Amon Carter Museum of Western Art in Fort Worth, Texas, in the spring of 1966.

Clara and I traveled to Ghost Ranch to photograph the giant painting for *The Tribune* and the *National Observer.* The painting was waiting in the garage where it was painted. She said, "It was something I saw from an airliner, a kind of ocean of clouds." When I asked how she managed to paint such a gigantic canvas, which was almost too large for the garage, she said, "I stretched and sized the canvas myself, with a little help from my handyman. Then I prepared it for oils and painted it." She made it all sound as simple as whipping up bread pudding.

In order to paint the upper part of the canvas, O'Keeffe had to push two tables together to make a scaffold. It took her two months to finish the picture. "Sometimes I worked late into the night," the rather frail-looking artist said. O'Keeffe was seventy-eight when she painted *Sky Above Clouds IV, 1965,* as the picture was titled — by someone else.

Even the crew of workmen who in December 1965 moved the giant painting out of the garage and into a truck for its ride to Fort Worth had problems. Mitchell A. Wilder, the museum director who supervised the move, said he was "pleased to report that everything went quite well, although we did have a few harrowing moments in the Ghost Ranch garage as the storm began to drive snow in through the opened door." He added, however, that all went well, "and the painting is now back on its original stretchers and safely resting in the Museum vault."

O'Keeffe was excited about the opening of the big Fort Worth show and invited us to join her. We were unable to attend, but the artist gave us a glowing report when she returned to Abiquiu, literally bursting with

enthusiasm. She sat down and wrote us a letter. There could be no doubt about her excitement. I have kept the letter these many years. It reads as follows:

3/21/66 Abiquiu
Dear Mr. and Mrs. Looney

I owe you thanks for many things — photographs — more photographs and more photographs — and it is now flowers that were lovely and such a surprise — Also your notices in The Tribune — which someone took to read and passed on to someone else and it never got back to me. Will you please send me another so I have one in my clippings.

I should thank you for it now as with my triffling [sic] ways probably will not get to it later —

I wish you could have been at the opening of the exhibition. They say there were over 2,000 people there.

To me it looked very well. We made the galleries over — all white and just fine looking — and Mr. Sweeney as usual made it look very beautiful —

You must go to Houston for the opening if I go down there —
But I hope you can go to Ft. Worth —

A number of old friends were there and that was very pleasant — Then there were a number of people I knew long ago and did not remember.

I was very interested in it all but it is really hard work. By the time I arrived home I had had enough —

Sincerely,
Georgia O'Keeffe

The letter demolished any idea that the artist was really an aloof recluse who preferred privacy to such things as recognition and attention. Basically, she was just like most of us beneath that shell she had so carefully crafted as part of the O'Keeffe image. She responded to love and caring, but because of her beloved "publicity" she didn't like to admit it.

O'Keeffe also took great interest in the book I was writing in the 1960s about the ghost towns of New Mexico and their inhabitants. The illustrated book, *Haunted Highways,* was published in 1969 by Hastings House and is still in print, now published by the University of New Mexico Press. She

supplied much encouragement as the book progressed, constantly asking me questions and also offering some excellent advice. When the book came out in the spring of 1969, we invited her to join us at an autograph party in the village of Corrales, an Albuquerque suburb. She was delighted and had her driver (an Abiquiu resident) bring her down in the Continental.

I had prepared more than 120 mounted enlargements of my own pictures and old photos that were included in the book. O'Keeffe zestfully took charge of arranging the mounted pictures around the room and even hung quite a few herself.

Her willingness to make the two-hundred-mile round-trip for us was a typical example of her warmth and humanity. She had turned eighty the previous November, but you'd never have guessed it by her appearance and energy.

In 1968 I had been promoted to assistant managing editor of *The Tribune,* which caused us to see less of O'Keeffe and more of such places as California and South Vietnam. A New Mexico Air National Guard unit had been mobilized and sent to the war zone. I organized a *Tribune* project to film Christmas messages from troops' families, then took the five miles of film we produced to their base at Tuy Hua on the South China Sea to screen them for the guardsmen.

Later, I spent nearly three months on the Navajo Reservation, doing a series on poverty and deprivation in the nation's largest tribe. This series won the Robert Kennedy Journalism Award for outstanding coverage of the problems of poverty and discrimination. This in turn led to an invitation from *National Geographic* magazine to do a lead article on the Navajos and several more months on the reservation.

Those were hectic years for us, and then in March 1973, I was named editor of *The Tribune,* with total responsibility for the newspaper. O'Keeffe was delighted with our good fortune. By this time, she had finally revealed to me that she had a phone in the Abiquiu house.

I'll not soon forget her phone call to me in 1972. She was excited. "I've just been told by a friend that I'm on President Nixon's enemies list," she laughed. "I think it's just wonderful if I am, but I want to be sure. Can you find out for me?" I could and did. I phoned my friend Dan Thomasson, who was covering the White House for Scripps Howard News Service. He

checked and found that, sure enough, she was on the list, along with a few hundred others.

When I phoned her the news (fortunately, she had given me the number), she was absolutely ecstatic. "Oh, that makes me so happy!" she cried. She hated Nixon and the Republican administration as passionately as she had Adolf Hitler, and to be included among their enemies she considered the highest honor. I'm certain she spent most of the day phoning the "good" news to her close friends.

Five years afterward, however, this dedicated liberal happily accepted the country's highest honor, the Medal of Freedom, from Republican president Gerald Ford. And it was richly deserved. So, too, was the honor of being among the first recipients of the National Medal of Arts from President Ronald Reagan at a White House luncheon in 1985.

Regrettably, we saw less and less of O'Keeffe through the remainder of the seventies. And in September 1980, I was, without warning, uprooted from my editorship in Albuquerque and transferred to Denver to become editor of the *Rocky Mountain News*. Scripps Howard owned both newspapers. The *News* was the company's flagship publication.

Literally overnight I was thrust into the center of one of the last great American newspaper wars. Those were long and exciting days building a staff that made the *News* number one in Denver circulation, ahead of *The Denver Post* by 130,000 papers on weekdays and solidly ahead on Sunday. But it required long hours and left little time for ourselves.

We never saw our old friend again, except for an occasional stray news item.

And then came March 6, 1986.

I think it was Charlie Able, our telegraph editor, who broke the news to me in midafternoon. Georgia O'Keeffe had died in a Santa Fe hospital at age 98. It was a shock. I immediately phoned Clara, who was as close to the artist as I was. I spent a good deal of time that afternoon staring westward through my office window at the snow-capped peaks of the Front Range of the Rockies glittering in the sun like white diamonds fifty or sixty miles away, remembering.

Suddenly I wondered why — in spite of her love of nature — she never painted those mountains. Probably, I thought, it was because they were too "pretty," too ordinary, not different enough. And she was certainly differ-

ent, in so many ways that couldn't be defined. The doors to her inner self only opened for close friends and then were soon closed off before too much could be revealed. We had been mightily honored that she'd invited us in for those precious hours and minutes.

Virtually everything she painted was that way. What talent! For some reason, I suddenly remembered the time she told me, "Oh, I wish I could sing! Wouldn't you like to be able to sing? I paint because I can't sing. I think if I have a next life, I would like to sing in it!"

It was about that time that the phone rang and interrupted my reverie. The secretary was out and I picked it up. It was a man calling from *The New York Times.* He asked if I had heard of O'Keeffe's death. "We have a photograph of her that you took and would like your permission to use it," he said. I was reasonably certain *The Times* had gotten the picture from the Downtown Gallery, the one to which I was always sending 8-x-10-inch prints of that photo she liked so much. I asked him about that, but he didn't know. "She really liked that picture," I told him. "You have my permission." Sure enough, it was that same favorite picture that appeared on *The New York Times* front page the following day with the story of her death.

I'm certain Miss O'Keeffe would have been delighted with the selection and the front page treatment. She would also have been most pleased at some of the things said about her in Edith Evans Asbury's *Times* obituary. For example, "As an artist, as a reclusive but overwhelming personality and as a woman in what was for a long time a man's world, Georgia O'Keeffe was a key figure in the American 20th Century. As much as anyone since Mary Cassatt, she raised the awareness of the American public to the fact that a woman could be the equal of any man in her chosen field." And this: "As an interpreter and manipulator of natural forms, as a strong and individual colorist and as the lyric poet of her beloved New Mexico landscape, she left her mark on the history of American art and made it possible for other women to explore a new gamut of symbolic and ambiguous imagery."

The world had lost an artistic giant. And Clara and I had lost a dear friend. Something special, something as unique as that rock she had held for us in her powerful and delicate hands was gone forever. There was a big hole in the sky, never to be refilled.

Chapter Six
Afterword

Ironically and sadly, at the ripe age of eighty-four, the intrepid Georgia O'Keeffe learned that there were some things even her iron will could not overcome.

In late 1971, the color-saturated world of the great artist began to dim as she began losing the one thing absolutely necessary to her work: her eyesight. One day the woman who so worshiped the brilliant southwestern sunshine noticed the sky had inexplicably turned to murky gray. Even worse, it remained that way in the days that ensued. Alarmed, she hastened to consult eye specialists, first in New Mexico, then California. They were, of course, the best available, and their diagnoses were in agreement. The verdict was devastating.

She was found to be a victim of macular degeneration, an incurable condition of aging involving the retina. It first afflicts central vision and eventually destroys it totally. Peripheral sight remains for a while but in time also fades and finally disappears altogether.

It is difficult to imagine the impact of such gargantuan tragedy on any individual. But for an artistic giant such as O'Keeffe it must have been comparable to a sentence of death. For a lifetime, she had depended on those penetrating blue eyes. It was through them that she saw a world usually considered mundane as a wondrous, spectacular place of fun and fulfillment. O'Keeffe's world was a garden of brilliant colors and mysterious shadows and images previously unseen. It was through those razor-sharp eyes that she found beauty and order in subjects others were blind to.

O'Keeffe's vision extended far beyond that of ordinary mortals. It revealed to her the perfection of the most common objects: mere rocks, tumbled and polished by roaring rivers or wind-whipped sand, and bare

bones bleached white by desert sun. Those O'Keeffe eyes missed very little, if anything. In the sky, they saw shapes and colors others had never seen — the evening star glittering brightly, somber images of purple cloud and exciting hot yellows and reds and oranges. They saw new lines and shapes and hues in mountains and sandstone cliffs and New York City buildings, smoky and mysterious. They saw everything from glorious green trees to adobe churches and black Penitente crosses on lonely New Mexico hills. The same orbs saw visions of flowers magnified to enormous size, revealing their innermost secrets, exposing unique hidden beauties.

What O'Keeffe's amazing optics saw, she painted for all the world to see and admire and love. She was able to combine reality with imagination and create magical images. And she was always tirelessly observing, watching, spying on the world to show those images to the rest of us.

Through her eyes she discovered extraordinary things to paint, whether it was the texture of mountain and cliff or the lines made by desert rivers viewed from thirty-five thousand feet above the Middle East. Or a hollyhock against a cloudy sky glamorized by the skull of a ram's head with twisted horns. Bones. The bloom of a jimsonweed. A blackbird in the snow. A dead tree against a pink hill. A ladder in the sky. Lonely canyons. Dunes. Blacks and whites and spectacular color.

Was this to be the end of the joy she had savored for so long?

The prospect of losing this marvelous gift must have sent O'Keeffe's mind reeling. The world she had cherished since childhood on the farms and vast fields of Sun Prairie was about to disappear forever. Those eyes had been the key not only to that lovely world of hers but also to respect and fame and wealth and power. They had opened doors for her everywhere, provided her with universal acclaim and honor upon honor.

The prospect of total blindness might have been enough to shatter an ordinary mortal, but O'Keeffe was the last thing from ordinary. Throughout her life she had prized her independence, reveled in her strength of will. She now faced the ultimate test, and *surrender* was not in the lady's lexicon. She came to grips with this tragedy, as she had with others throughout life. She told one close friend that it was probably a good thing that the blindness would not come all at once, that the gradual loss of sight would prepare her for what was to come.

She decided to make the best of things, to learn to live with the tragic hand that fortune had dealt her. She began by telling only her family and very closest friends of her condition. Among them was Virginia Robertson, who became O'Keeffe's secretary and companion in the summer of 1971. O'Keeffe was very careful about secrecy. Clara and I visited her in 1973, and she never mentioned her eye problem, giving us no inkling that her vision was impaired. I'm certain her reason was the fact that I was a newspaperman. Some of the photographs I took that day betray no clue to her condition.

When Mrs. Robertson decided to return to Albuquerque in 1973, O'Keeffe tried to get her to stay. Author Roxana Robinson, in her excellent book *Georgia O'Keeffe — A Life* (New York: Harper & Row, 1989), reports that O'Keeffe had come to depend on Mrs. Robertson and offered to raise her wages and build her a home nearby if she would remain with her. But Robertson still declined. The book also reveals that after O'Keeffe's last effort to retain Robertson failed, the artist said, "Well, no one is ever going to leave me again."

Clearly, O'Keeffe had finally recognized that she could no longer operate on her own without someone on whom she could depend. Fortunately for her, fate (or maybe a guardian angel) provided that someone soon afterward, one who would never leave her.

It was the very next day that John Bruce Hamilton, usually called Juan, showed up at the O'Keeffe house looking for work. The tall, lean, rather handsome twenty-six-year-old wore his long hair tied in a ponytail. A heavy Wyatt Earp–style moustache graced his upper lip. He had been working for some time at Ghost Ranch headquarters, mostly in the kitchen, and was down on his luck.

Hamilton was a typical product of the 1960s, something of a restless drifter trying to find himself and a place in the sun. He was a conscientious objector to the Vietnam War. Born in Dallas, Texas, the son of a Presbyterian lay worker and teacher, he spent much of his childhood in Costa Rica, where his father taught at a seminary and where Juan learned to speak fluent Spanish. He graduated in 1968 from Hastings College in Nebraska, attended Claremont grad school for a semester, then got married. The union lasted two years and ended in divorce.

O'Keeffe paid little attention to Hamilton on his first two visits. On the third, she asked him to crate a painting for her, which he did to her satisfaction. Three or four weeks later, O'Keeffe told an interviewer that she was trying to get Juan to build a kiln for his pottery. It proved to be the beginning of a relationship that was to last to the end of her life.

As the months passed, the friendship flourished. O'Keeffe quickly discovered that her handyman was educated and intelligent. She also approved his interest in art and the crafting of pottery. O'Keeffe, her eyesight continuing to fade, even tried her hand at working with clay. She also found he was a skilled typist and soon had him typing her letters.

O'Keeffe knew a good thing when she saw it. She quickly recognized that fate had presented her with a precious gift that she sorely needed. Before long, Hamilton was helping O'Keeffe with her business affairs, including the sale of her paintings. Early in 1974 Juan and O'Keeffe traveled to Morocco on a holiday. Soon afterward he moved out of the trailer he'd been living in and into the O'Keeffe house at Abiquiu. Soon Juan was answering her phone, making appointments for her and taking walks with her in the desert. She assigned him the job of putting together the book *Georgia O'Keeffe,* which included much autobiographic material as well as a great many of the artist's best-known works. The volume, published by Viking in 1976, was a huge success, thanks to Hamilton's careful selection of paintings and his general supervision.

For Hamilton, it must have been rewarding to work for a woman of such legendary artistic fame; he was able to purchase a house in the nearby village of Barranca within a year of his arrival at O'Keeffe's. However, it could not have been an easy life for Hamilton. O'Keeffe was a forceful woman used to getting her way. She demanded the absolute most from her employees. As the artist grew older, she needed more help than ever. Juan often spent eight to twelve hours a day six days a week working for O'Keeffe.

By 1978, O'Keeffe had entered her nineties, and her age was showing up in increasing weakness. Her eyesight was almost gone. On January 5, O'Keeffe signed a broad power of attorney giving Hamilton sole control of her property, assets and business, including discretion to "empty safe deposit boxes" and hire and fire employees. O'Keeffe, unable to read the

document, wrote on it that she had had someone read it to her and signed her full name, which was notarized. The document did not become a public record until April 30, 1984, when Hamilton filed it with the Santa Fe County Clerk when he bought a Santa Fe mansion in O'Keeffe's name for $2 million. The purchase was made to locate O'Keeffe near a hospital after she suffered a heart attack.

In 1979, O'Keeffe wrote a new will, which named Hamilton executor and forgave any debts he might owe her and left him the Ghost Ranch house. She also left twenty-one paintings to him, and fifty-two others to eight museums. Most of her remaining pictures were bequeathed to charitable institutions to be chosen by Hamilton. The Abiquiu house was left to the National Park Service.

Juan Hamilton was married in 1980 to Ann Marie Erskine, twenty-six, of Phoenix, Arizona. Hamilton said that Miss O'Keeffe approved. The union produced two sons.

By 1982, O'Keeffe's increasing weakness was apparent to visitors to Abiquiu. She was ninety-five. Her eyesight was virtually gone, and she had become totally deaf.

In November 1983, a first codicil was added to the O'Keeffe will. This one eliminated the bequest of the Abiquiu house to the Park Service and directed that it be given to a charitable organization or that it be sold and the proceeds given to charity. Hamilton continued as executor but was now to receive $200,000 for his services. He was still to receive the twenty-one paintings.

Meanwhile, the value of O'Keeffe's art was soaring. Her painting *White Rose, New Mexico* was auctioned by Sotheby's for $1.3 million in 1985, a record for an O'Keeffe. Court records were to show that in the nine weeks O'Keeffe was alive in 1986 her taxable income was $1.1 million.

The beginning of the end occurred in 1984, when O'Keeffe was ninety-six. Her sister Claudia died at age eighty-five. O'Keeffe flew to Florida to visit another sister, Anita. While she was there, she suffered a heart attack. This convinced Hamilton the artist should be closer to a hospital. The Sol y Sombra mansion was available. Hamilton purchased it in O'Keeffe's name from friend and business associate Gerald Peters. A tract next to the property was bought in Hamilton's name. Hamilton also pur-

chased three new Mercedes-Benz cars, a station wagon, a sedan and a convertible in O'Keeffe's name.

The eighth day of August 1984 was marked by a strange event in the mansion: O'Keeffe awoke and told her on-duty nurse she wanted to dress in only white that day. She told the nurse she was "getting married to Juan today." Apparently O'Keeffe was confused by the fact that the mansion was overflowing with flowers from the garden that day. Many old friends came calling. One, a doctor, took a sample of O'Keeffe's blood.

Months later, David Johnston, a *Los Angeles Times* writer, reported that Hamilton said he was "astonished" to learn that the household staff believed he had married her. He called it "ridiculous," adding, "I was already married, so how could I marry Miss O'Keeffe?"

Instead of a marriage, what happened that day was that O'Keeffe signed a second codicil that made big changes in all other O'Keeffe wills. Prior to this codicil, most of the estate was to go to charitable purposes. This new one left some 70 percent — almost everything — to Hamilton. This was a substantial amount, as the paintings alone were estimated to be worth $65 million, not including other property. The codicil was witnessed by Benjamin Sanders and his wife, O'Keeffe friends for many years. The codicil was read to O'Keeffe and approved by her.

Soon after O'Keeffe's death in March 1986, Juan Hamilton filed the will. Four weeks afterward, two O'Keeffe relatives filed a court challenge against Hamilton. Both Catherine Klenart, O'Keeffe's only surviving sister, and grandniece June O'Keeffe Sebring claimed Hamilton had used "undue influence" to get the artist's signature on the second codicil.

Months later, Hamilton agreed to a settlement in which he gave up much of the O'Keeffe millions. The Klenarts and Sebring each were to get $1 million in art. Their lawyers split $1.8 million in fees. Hamilton kept the gifts left him under the 1979 will. The assets he gave up founded the non-profit Georgia O'Keeffe Foundation. Hamilton was quoted in newspapers as saying he settled for many reasons, notably a desire to get on with his career as a potter. He called the settlement a huge emotional relief. "If I were to fight this, spend ten or fifteen years, it would be an entire career, and neither Miss O'Keeffe nor I ever intended that."

The haggling between the heirs and the government went on in court for six years after O'Keeffe's death. Four hundred works of art were the issue. The U.S. Tax Court finally valued the art at $36.4 million. Judge Mary Ann Cohen rejected arguments on both sides and split the difference between the estimates of how much O'Keeffe's art should be discounted and, as a result, how much the IRS was owed. She discounted half the art works by 75 percent and the other half by 25 percent, valuing the estate at $36.4 million for IRS property tax collection.

≈

After the move to Santa Fe, the famed artist had round-the-clock nurses. Many visitors found her very quiet. She was said to have spent most of her days sitting in her big room at Sol y Sombra, turned toward the light streaming through the windows, waiting, saying very little. Even then, in her ninety-eighth year, blind and deaf, she remained fascinated by the warmth of the southwestern sun.

I have to wonder in her remaining moments of lucidity if she ever realized what a marvelous gift she had given the world. Probably not. But in the end, as usual, O'Keeffe got her way. As she directed, her remains were cremated and scattered across the bone-dry sand and rocks of the Ghost Ranch country she worshiped.

It seems somehow appropriate that this strong-willed giant who painted the hard land so beautifully has now merged with and become a part of that country, the place where she loved to listen to the wind and watch the thunderheads gather over her very own mountain.

In death, as in life, she remains unique.

Abiquiu, N.M.
3/21/66

Dear Mr. and Mrs. Looney,

I owe you thanks for many things
— photographs — more photographs
and more photographs — and now
it is flowers that were lovely and
such a surprise — — Also your notice
in the Tribune — which some one took
& read and passed on to some one else
and it never got back to me. Will you
please send me another so I have one in
my clippings . I should thank you for
it now as with my triffling ways I
probably will not get to it later —
I wish you could have been at the
opening of the exhibition . They say there

*O'Keeffe letter dated 3-21-66. This warm letter was written by Georgia
O'Keeffe following a giant showing of her art at the Amon Carter
Museum in Fort Worth, Texas.*

were over 2000 people there. To me it looked very well. They made the galleries over — all white and fine looking — and Mr. Sweeney as usual made it look very beautiful — You must go to Houston for the opening if I go down there — but I hope you can go to Ft. Worth — Remember of all friends was there and that was very pleasant — Then there were a number of people I knew long ago and did not remember.

I was very interested in it all but it is really hard work. By the time I arrived home I had had enough.

Sincerely

Georgia O'Keeffe

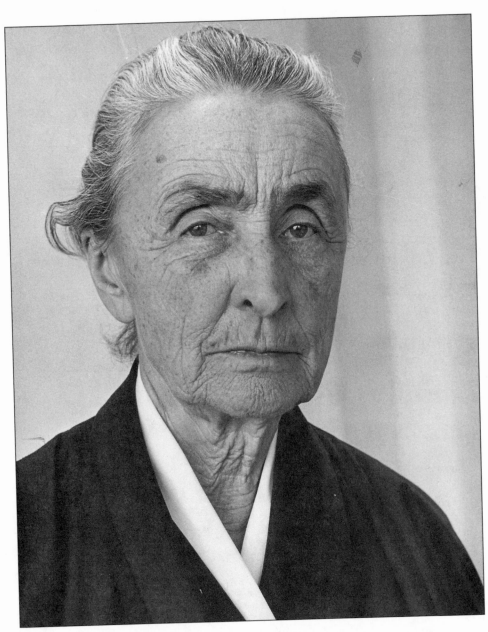

O'Keeffe's favorite of my photographs of her, made in her Abiquiu studio during our first session in May 1962. It was used on the front page of The New York Times *upon her death in 1986.*

> Abiquiu, N.M.
> 5/17/62
>
> Ralph Looney
> 2814 Arizona St. N.E.
> Albuquerque, N.M.
>
> Dear Mr. Looney :
> I will be at home Sunday Morning,
> May 20th . if you wish to come.
>
> Sincerely
> Georgia O'Keeffe —

O'Keeffe note responding to my letter. The bold strokes of the artist's pen say worlds about her. It was delivered the day before our meeting was planned.

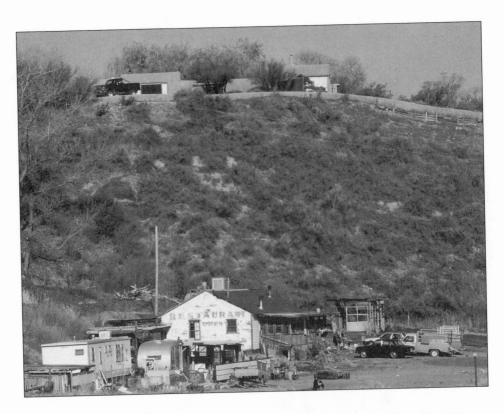

O'Keeffe's Abiquiu house. Although the "queen" is gone, her brown adobe "castle" still clings solidly to the bluff above U.S. 84. She purchased the house from the Catholic Church in 1949. It was a shambles until she restored it. At her death, ownership passed to the Georgia O'Keeffe Foundation. The well-kept house remains in odd contrast to its neighbor (a former restaurant) just below.

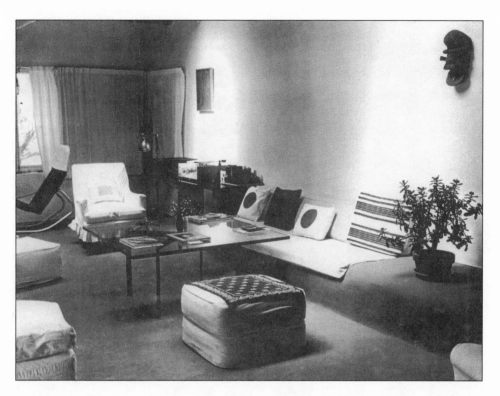

Living room in O'Keeffe house. O'Keeffe's house was spartan but neat and eminently clean. The pillows emblazoned with the Japanese rising sun rest on an adobe banco *(sofa). The floor is adobe.*

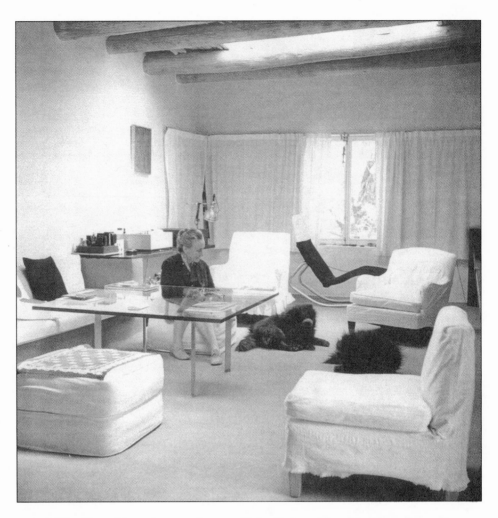

O'Keeffe and her chows at home. O'Keeffe loved her big blue chows, Bo and Chia. They had the run of her home, as is evident in the photograph.

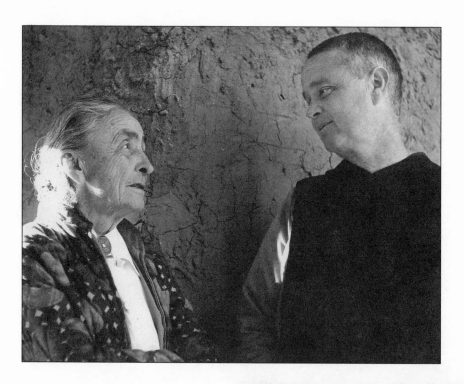

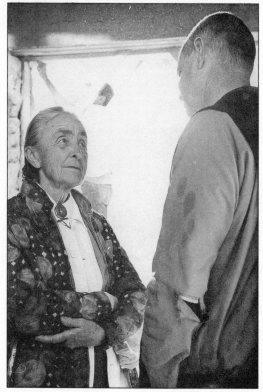

Photos of O'Keeffe and Benedictine monk. O'Keeffe loved remote places like the Monastery of Christ in the Desert, founded by Benedictines in the lonely valley of the Rio Chama, thirteen miles by dirt road from her Ghost Ranch house. She often attended services there. She is shown with Father Aelred.

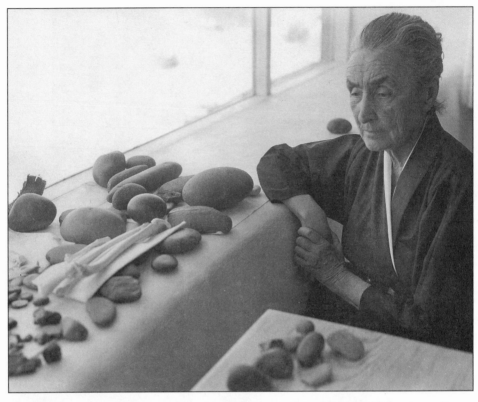

Photo of O'Keeffe with rocks and window. O'Keeffe enjoyed showing off her rock collection to visitors. Here she poses pensively with some of her "treasures," as she called them, on a windowsill.

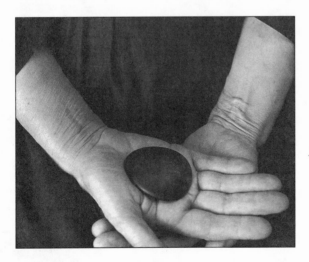

O'Keeffe's hands holding one of her favorite black rock treasures.

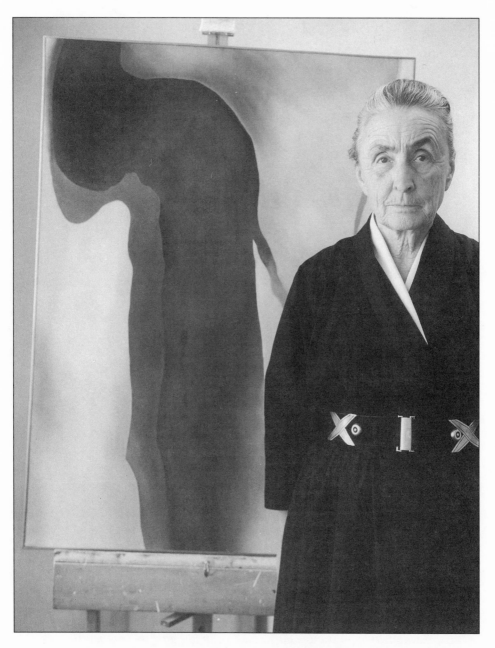

O'Keeffe with blue painting. The artist poses wearing her robelike dress set off by silver settings on the belt.

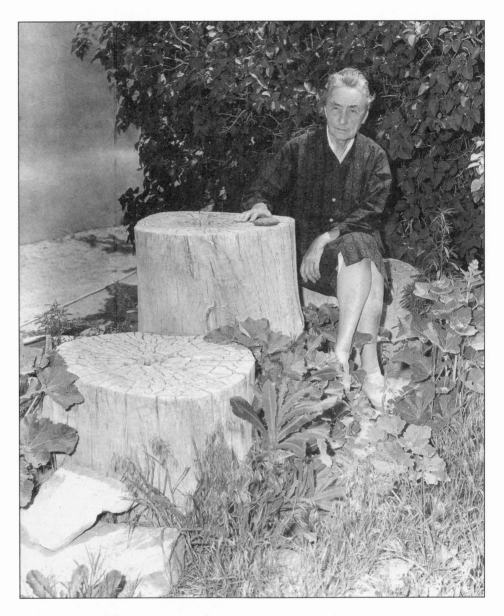

*Georgia O'Keeffe, the passionate lover of nature and gardening, poses
with two huge stumps that were two of her garden ornaments.*

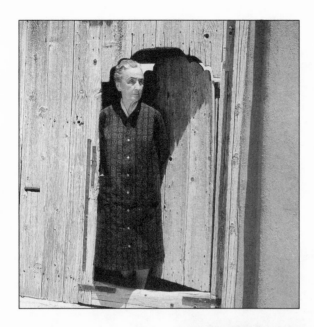

O'Keeffe at the gate through the adobe wall of her Abiquiu home.

O'Keeffe in her garden. She seems right at home working in her hot frame of lettuce. She devoted much of her life to gardening.

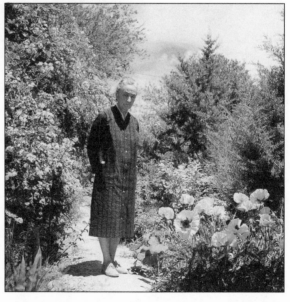

O'Keeffe and her hollyhocks. The artist loved flowers both in her home and out.

O'Keeffe's Christmas card. In 1963 we received this card from O'Keeffe, a reproduction of a 1917 painting called Starlight Night *only slightly reduced from the 9-x-12-inch original. The greeting was handwritten by the artist in the usual bold style.*

June 17 – 73 – My first Xmas Card

恭　SEASON'S GREETINGS

賀　MEILLEURS VOEUX

新　FELICES FIESTAS

禧　С НОВЫМ ГОДОМ

To Mr and Mrs Loomas

Sincerely

Georgia O'Keeffe —

Another O'Keeffe Christmas card, with her words, "My first Xmas Card."
The 1946 painting is entitled Black Bird with Snow-Covered Hills. *Its design*
was contributed by the artist to benefit UNICEF.

An O'Keeffe notecard.
This unusual card sent to
us in January 1966
thanked us for some
unusual cheese.

Thanks you so much for
the very fine cheese — It is
very good indeed

But all good wishes
to both of you for 66 and
always —

Sincerely,

Georgia O'Keeffe

1/10/66 —

O'Keeffe and Haunted Highways. *Georgia made a one-hundred-mile trip to suburban Albuquerque in 1969 to attend an autograph signing for a book I had written,* Haunted Highways.

O'Keeffe with the huge 24-x-8-foot canvas entitled Sky Above Clouds IV, 1965,
the largest oil on canvas the artist painted. It is shown in the garage of her

Ghost Ranch home, where she did the painting. It was displayed for the first time at a huge showing of O'Keeffe's paintings in 1966 in Fort Worth, Texas.

Images: The Many Faces of Georgia O'Keeffe

One thing I learned quickly from my friendship with Georgia O'Keeffe was that she had an ongoing passionate love affair with the camera. While insisting that she hated being photographed, she proved to be an amazingly docile model who clearly enjoyed her role. She was perfectly comfortable and eager to please.

In fact, I have never seen anyone so perfectly at home in front of a camera. I assumed that she had learned her patient role through endless photographic sessions with Alfred Stieglitz over the years of their marriage. Stieglitz, one of the country's premier camera artists, took hundreds, perhaps thousands, of shots of this woman he loved, including nude studies.

She was splendidly photogenic, with clear, luminous blue eyes in an unforgettable face etched with a veritable spiderweb of deep wrinkles. The skin was deeply tanned, burnished to the color of old, soft leather by the blazing southwestern sun. Unlike most mortals, who shudder at the appearance of such marks of aging, O'Keeffe seemed to glory in those wrinkles, knowing full well what they did for her image. And she was a perfect model who photographed well from any side in any position.

In our first meeting she appeared somewhat coy, saying she didn't know my work. But she finally agreed to pose when I ignored her and began getting out my equipment. From this first encounter, the artist

showed complete patience, understanding and cooperation, even allowing me to choose the backgrounds. It was the same throughout our friendship. She never complained. She happily accepted direction and wanted the photographs to come out well.

The only complaints I ever heard from her concerned photos of smiling faces. But interestingly, she never objected to my photographs that revealed her beautiful smile. It often was radiant, particularly when she laughed. But still, O'Keeffe preferred that the public see her always in the mode of iron maiden, which she had crafted so carefully.

Only a few of these pictures have been published previously.

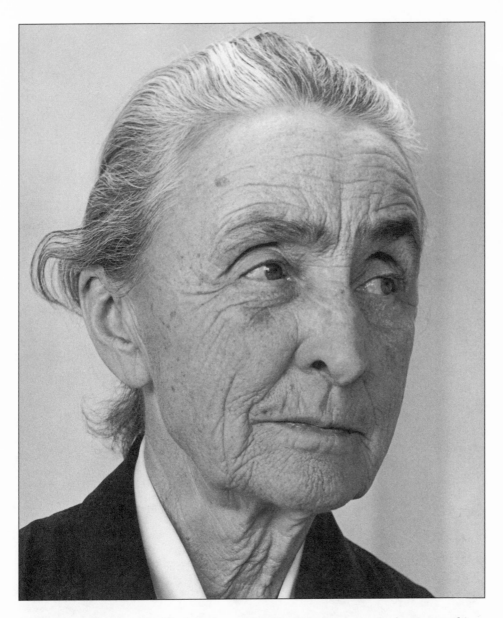

The Eyes Have It. The luminescence of O'Keeffe's eyes clearly dominates this photograph. They reflect patience with the stranger behind the camera, salted with perhaps a gram or two of skepticism and maybe amusement.

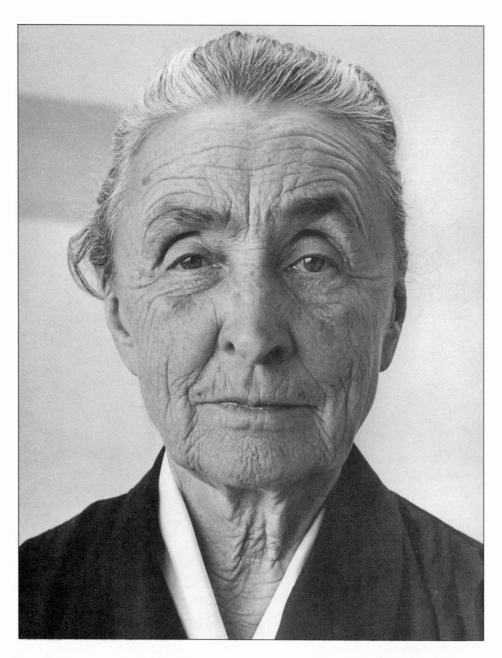

This is actually the first photograph made that day in May 1962. The lips reveal a hint of a smile, and the eyes some curiosity. Note the wild lock of hair on the right side of her head. The lock shows up in each picture that day. Obviously, she didn't care. She never looked at a mirror during the session.

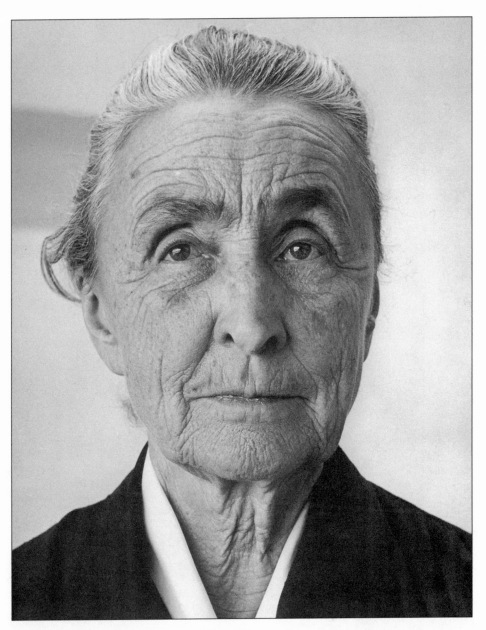

This photograph, also taken on our first day, reveals a hint of pixiness in her eyes.

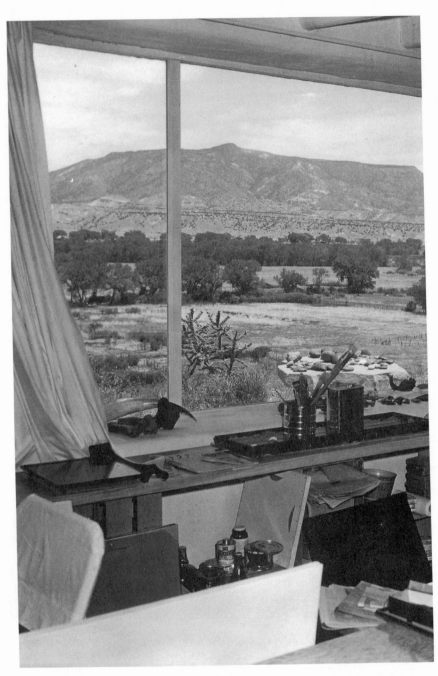

Georgia O'Keeffe sits on the adobe window seat in her studio and enjoys her spectacular panoramic view of the Chama River Valley. In the fore-

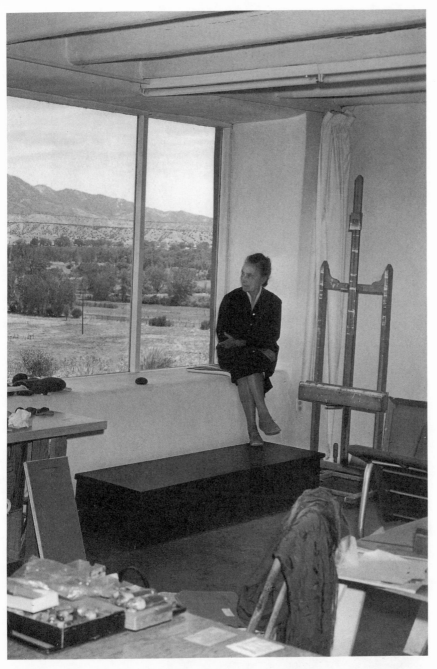

ground are work tables, paints and brushes. Some of her rock collection is
visible on a huge stone table immediately in front of the picture window.

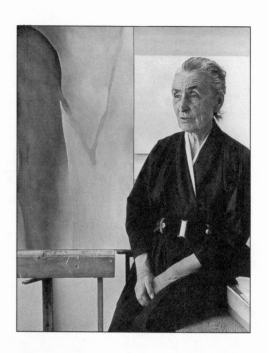

The artist with a painting in her studio.

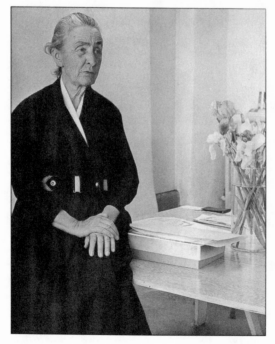

In Georgia O'Keeffe's home, flowers were always abundant. Here, the artist poses in her studio with a big bouquet of iris on the table.

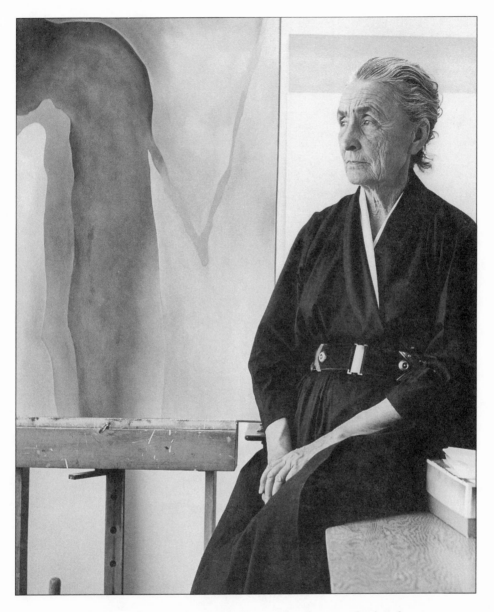

The artist in a moment of retrospection with a faraway look in her eyes.

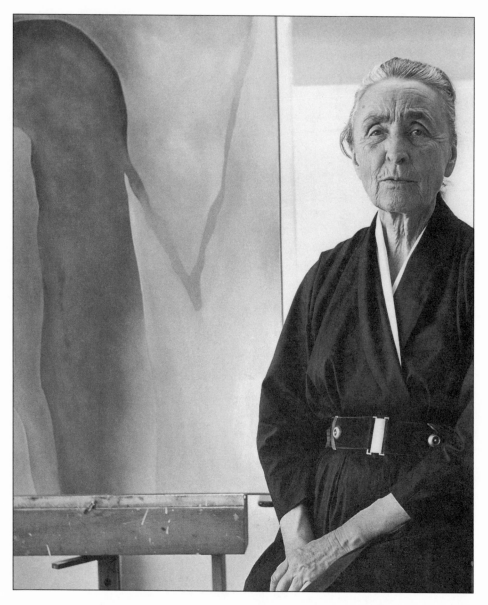

The artist assumes a regal pose.

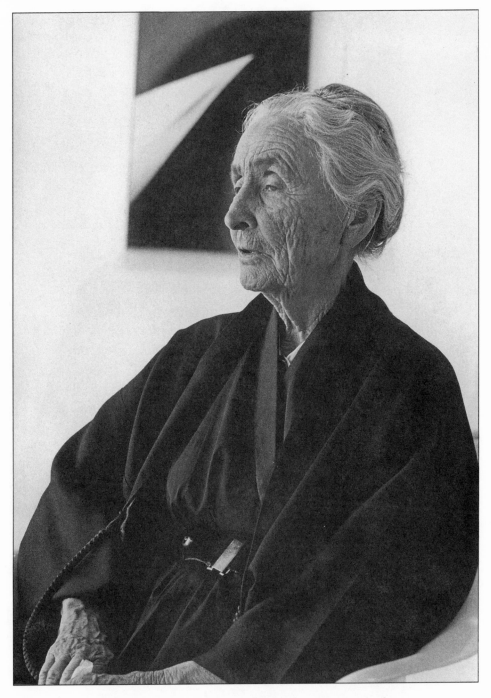

The artist listens with a somewhat inquisitive look.

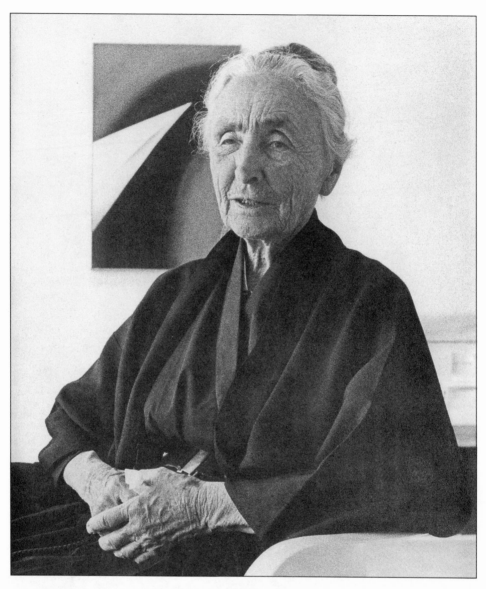

She makes a skeptical comment.

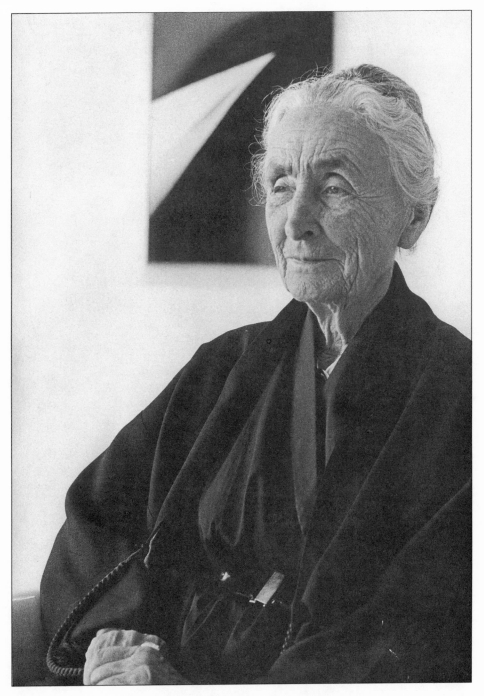

The artist smiles at a comment.

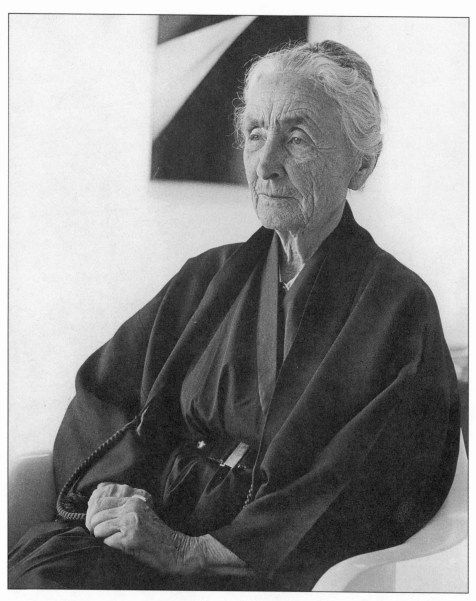

The smile begins to slip away.

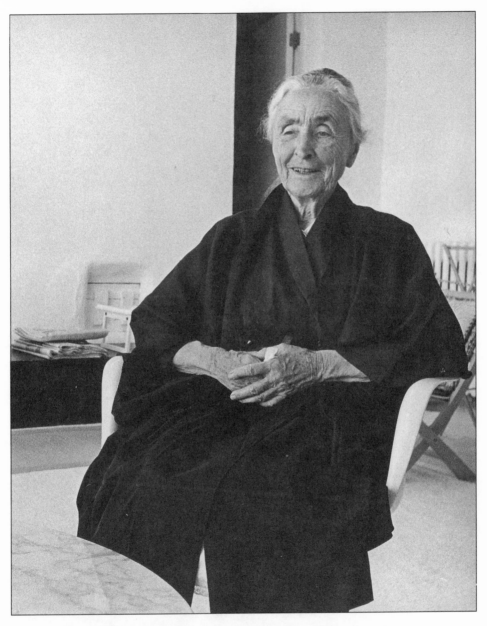

*Georgia O'Keeffe could enjoy a good laugh with the best of them.
She proved it here.*

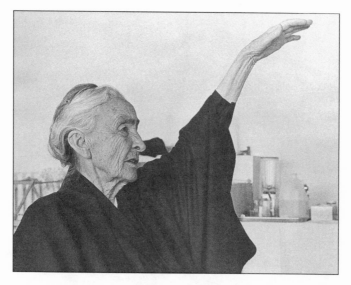

The artist raises her arm to illustrate the size of something she has seen. I was unable to hear just what it was, but she certainly was vigorous in her description.

The artist extends a finger as she emphasizes a point.

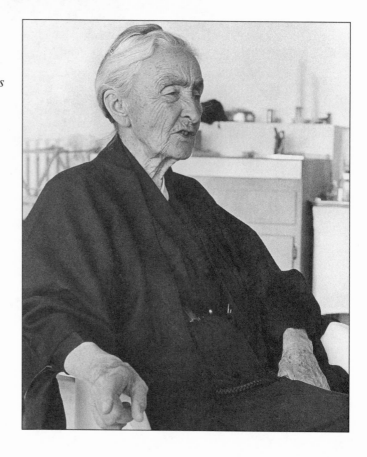

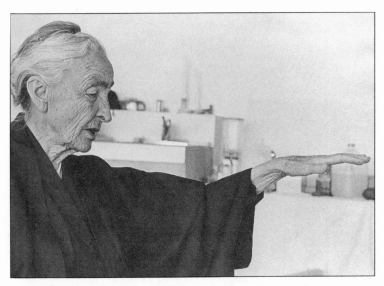

O'Keeffe raises her left arm to illustrate height.

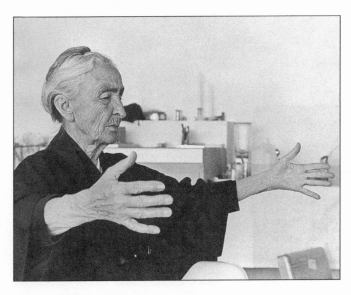

The artist illustrates the girth of the object.

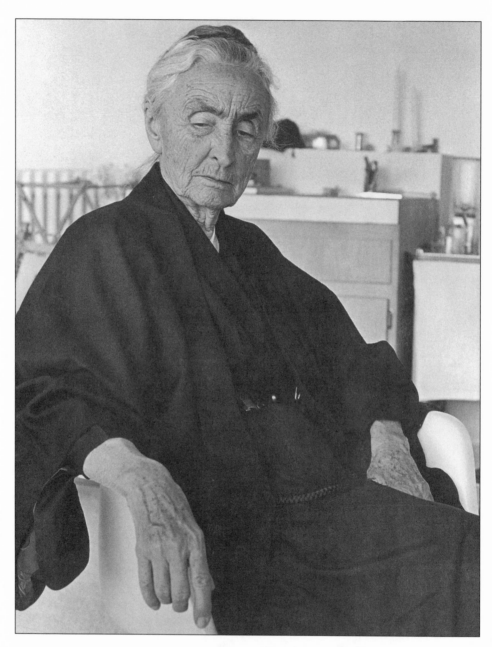

O'Keeffe brings her performance to a screeching halt.

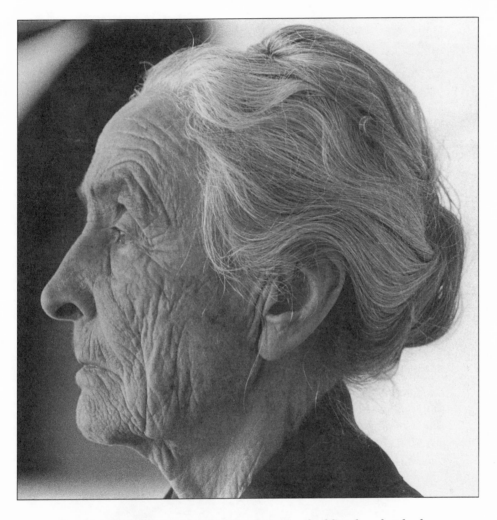

Georgia O'Keeffe preferred to be photographed head-on but had no objection when I made these profile close-ups. A portion of her painting Black and White, 1930 *is visible in the background. The artist was well into her eighties then but had lost none of her iron will, as this picture and the one that follows testify. Her wrinkles are sharply delineated in the two photographs, especially in this one.*

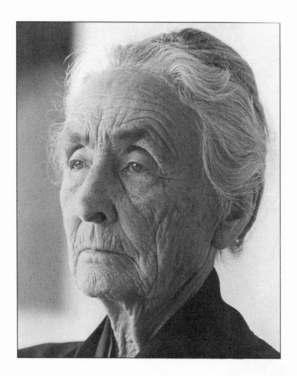

This vertical shot emphasizes O'Keeffe's strong visage.

This photograph shows the artist in the way she preferred; it certainly emphasizes her strength and determination.

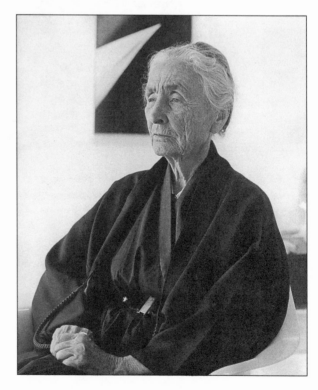

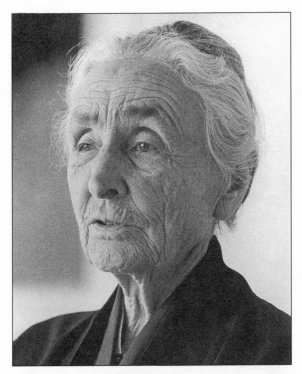

Here is the conversational O'Keeffe, clear-eyed and sharp in her eighties.

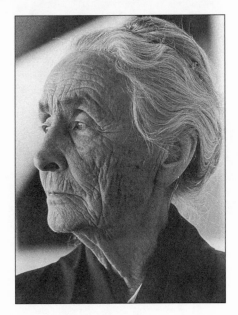

A rare three-quarter photograph of O'Keeffe, with a far-off look in her eyes.

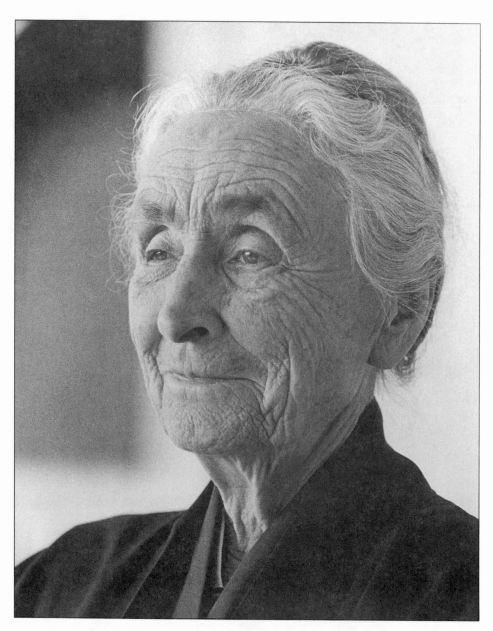

This is my favorite. The photograph shows the gifted artist in all of her warmth and love. This is the O'Keeffe who lived beneath the facade of remoteness she spent her life cultivating.

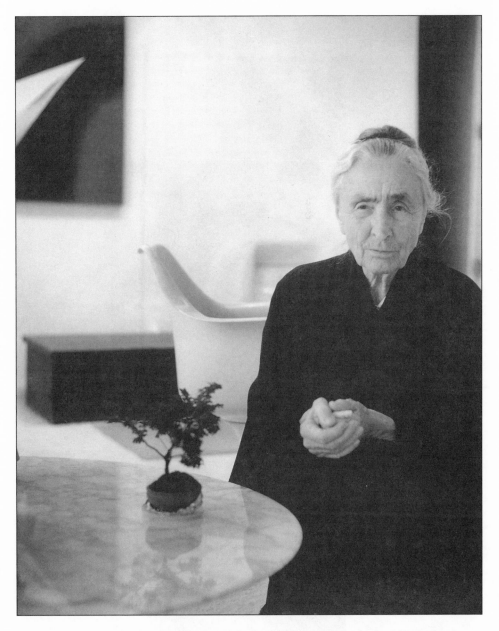

This photograph of O'Keeffe was taken in 1973. If the macular degeneration of her eyes had begun, she gave no indication then.

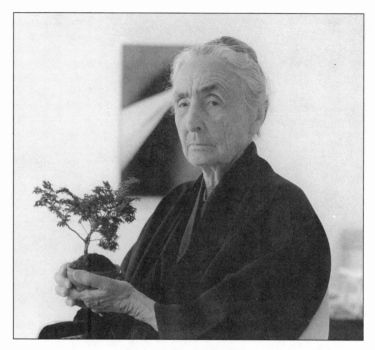

*In this photograph, also taken in 1973, O'Keeffe
displays a tiny Japanese tree.*

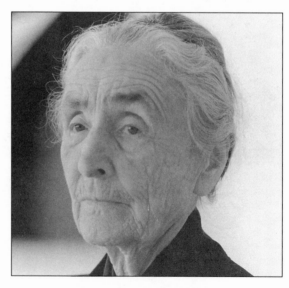

A close-up of O'Keeffe.

Images: The Rugged Face of O'Keeffe Country

When Georgia O'Keeffe discovered the wild, rugged and colorful Ghost Ranch country in 1934, she fell instantly in love. It was surely a perfect match that some might say was made in heaven. This land was an artist's dream, a place of lonely but lovely sunswept vistas of hill and mountain and rock-strewn desert, soaring cliffs and a tempest of colors glittering in the sun. She reveled in the combinations of color in the rocks, brilliant red and pink sandstone, combinations of green, chocolate, gray, purple, and even yellow and blue. She was overjoyed when she occasionally happened onto animal bones bleaching in the searing sun.

It was, in a word, extraordinary. Just like the artist herself. And it stimulated her to new heights of creativity in painting that enhanced her already growing artistic fame.

I hope these photographs will give the reader an idea of the country O'Keeffe loved so well and perhaps a better understanding of the artist.

These are places where O'Keeffe briskly walked her big blue chows in the early evenings as the sun sank slowly to the west, setting layered cliffs aflame with scarlet. These were the areas she explored and mountains and deserts she was familiar with, her curiosity all-consuming. They provided enough solitude and isolation to permit her to live and paint as she chose and enjoy the company of the friends she wanted.

Three types of cameras were used to make the photographs, my trusty Rolleiflexes, a 4-x-5-inch format Speed Graphic, and a 35mm Nikon.

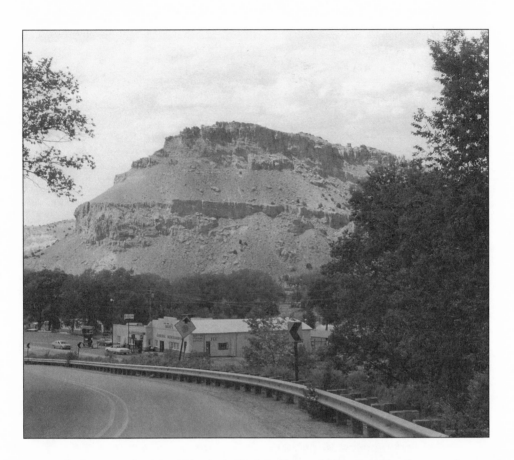

*The busiest place in Abiquiu is Bode's General Merchandise Store and
garage, which sells everything from gasoline and hardware to food and
clothing. It fronts on U.S. 84. The great sandstone butte visible behind Bode's
and just across the Rio Chama is Abiquiu's principal landmark. This view
is from the top of the hill on which most of the village is located,
including O'Keeffe's big adobe house.*

*Spaniards settled on the hill here in 1747 and brought Roman Catholic
clerics with them. The Church has flourished throughout New Mexico
ever since, especially in the old villages of the northern part of the state.
This handsome church was designed by the late John Gaw Meem in
modern times. Meem was a noted southwestern architect.
The church fronts Abiquiu's dusty town plaza.*

Evidence that the Penitente Brothers of Light are still active in northern New Mexico is this small adobe morada (chapel) on the southern edge of Abiquiu that overlooks the deep green Rio Chama Valley and the distant peaks of the Sangre de Cristos. The three crosses commemorate the crucifixion of Christ.

The secret brotherhood arrived in New Mexico with the first Spanish settlers in 1598. History records that their leader, Don Juan de Oñate, and his men performed public penance under the direction of Franciscan friars during Holy Week. Penitente processions re-enacting Christ's crucifixion are still common, with a sect member carrying the cross to the accompaniment of the shrill, otherworldly shriek of a pipe. In the past, sect members practiced self-flagellation until it was outlawed by the Church. If it continues today, it is done in secret.

This hand-carved figure of Christ carries the cross up the hill just across an arroyo from the Penitente church.

A climbing yellow rose brightens this house on the edge of Abiquiu's plaza. Yellow roses are highly popular in this old Spanish village.

This lovely spot along the Rio Chama is just outside of Abiquiu on a dirt road that leads to Barranca, a village a few miles north.

U.S. 84 borders the Rio Chama Valley north of Abiquiu as it begins to enter red rock country. The irrigated valley is rich farmland. Trees line the river on both sides. Irrigation ditches carry water to the fields. River water flow is controlled by Abiquiu Dam, about eight miles north of the village.

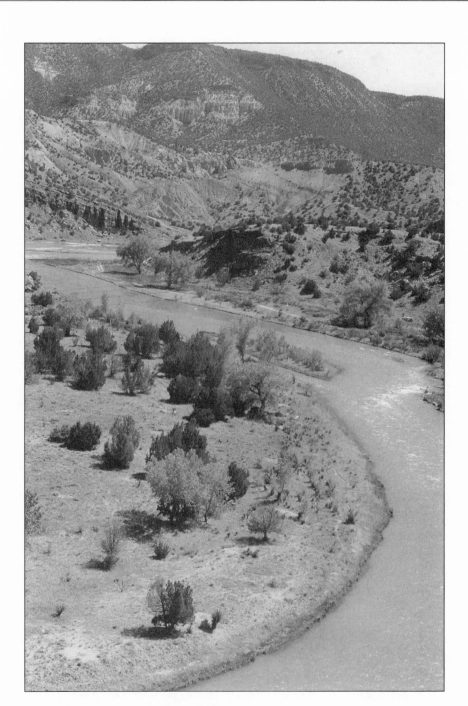

*Another view, taken north of Abiquiu, of the Chama River as it flows
southward through crimson canyons toward the Rio Grande.
O'Keeffe knew this country perhaps better then many of its residents.
She was a born explorer.*

Although Georgia O'Keeffe was enchanted with Abiquiu, its fables, its fascinating inhabitants and rich history, her preference was Ghost Ranch. She first laid her deep blue eyes on the place in 1934 and immediately claimed it as "my world." She loved its wildness and everything else about it, from the symphony of colors to the strange shapes of the rocks, layered like cake. Typical of the country is this towering cliff just off U.S. 84 about fourteen miles north of Abiquiu.

Not far away is another rock formation. The imaginative might see elephant heads, complete with trunks.

In this photograph a varicolored butte rears upward. The entire Ghost Ranch area is called the Gallina Fault Zone.

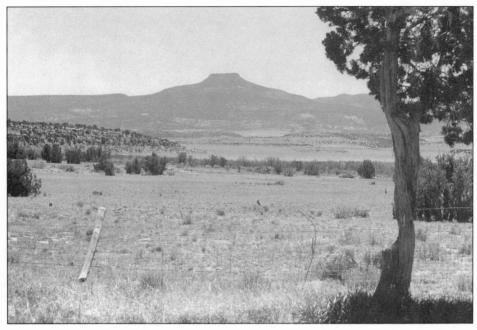

This is 9,862-foot-high Cerro Pedernal from a distance of some fifteen miles. The water visible is part of Abiquiu Lake Reservoir. O'Keeffe referred to it as her mountain. It appears in many of her paintings.

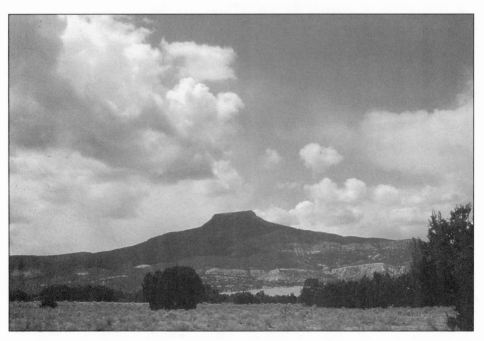

A closer view of Pedernal — which means flint in Spanish — on a sunny day.

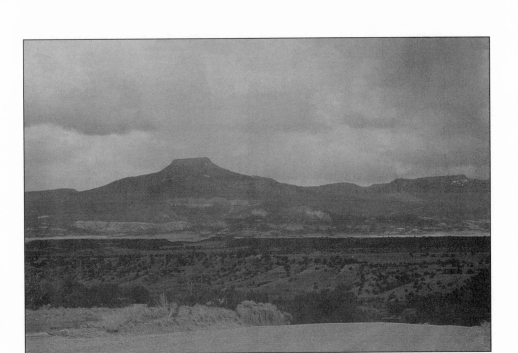

Another view of Pedernal as a storm gathers. The peak is the most prominent landmark in the area.

Mesa Montosa dominates the Ghost Ranch area. The Presbyterian Church Conference Center is nestled nearby. O'Keeffe's Ghost Ranch house is situated near the cliffs.

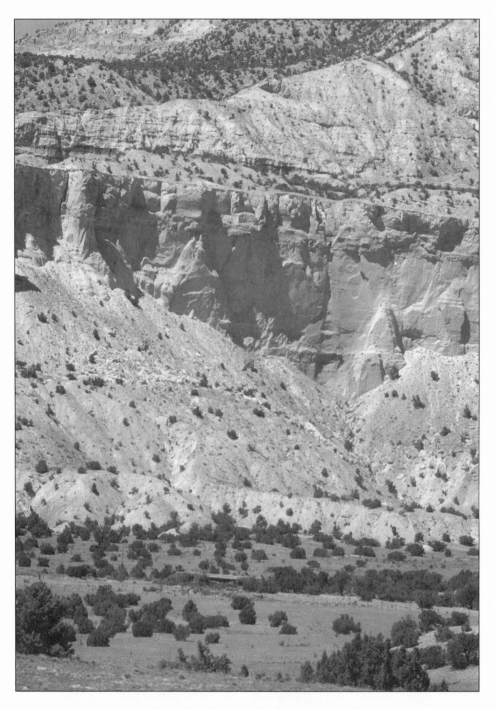

*A few adobe houses have been built near the Mesa Montosa cliffs,
including the one occupied by Georgia O'Keeffe.*

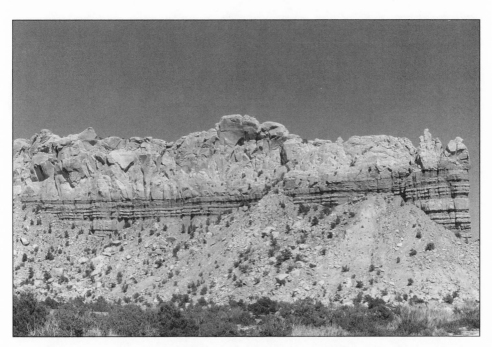

*Rock forms like this abound around Ghost Ranch. This strange sandstone
wall was eroded by wind and water over millions of years. The photograph
below shows a close-up of the "ear" shape. The entire Ghost Ranch country
is loaded with prehistoric remains of various life forms.
O'Keeffe found many in her wanderings.*

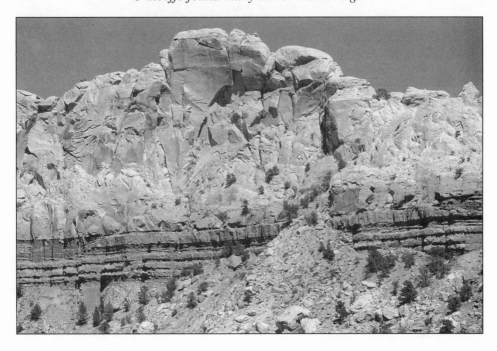

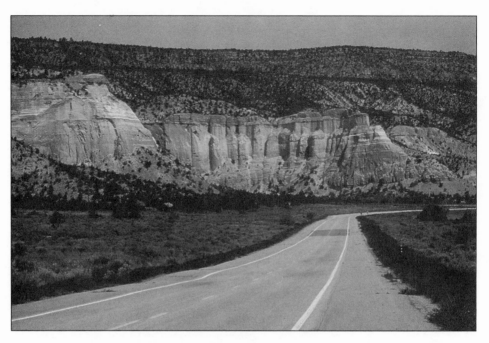

Seven images around Echo Amphitheater, a picturesque formation near Ghost
Ranch carved by erosion out of the sandstone mesa. Above: U.S. 84 heads
north by the echo cove in the mesa. Below: Layer cake of sandstone.

Echo Amphitheater. Sounds rebound perfectly here.

Arches carved by nature.

Pillars of sandstone created by nature.

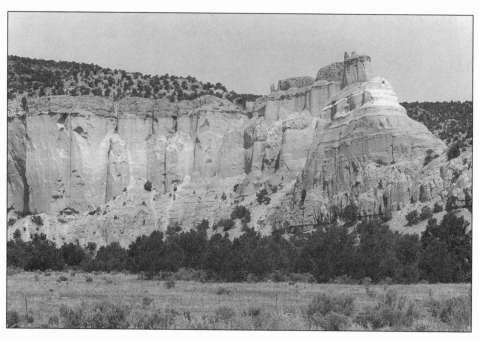

The watchtower that guards the amphitheater.

Close-up of the watchtower.

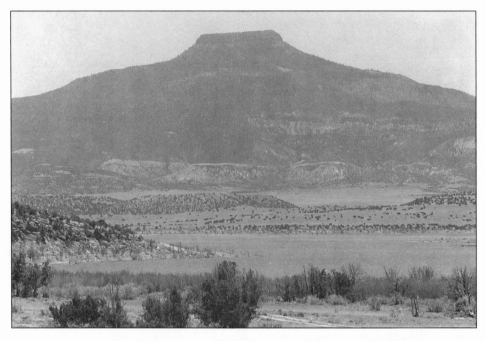

*Cerro Pedernal appears to be the guardian of Ghost Ranch in this
telephoto picture made from some fifteen miles away.*

Index